Copyright 2007

Publishing: Index Book SL.
C/ Consell de Cent 160 local 3 - 08015 Barcelona

Phone: +34 93 454 5547

Fax: +34 93 454 8438

E-mail: ib@indexbook.com

URL: www.indexbook.com

Printed in China ISBN: 978-84-96309-85-2
While every effort has been made to ensure
accuracy, neither Index Book nor the author
under any circumstances accepts responsibility
for any errors or omissions.

Author/Graphic Design: Pedro Guitton

Translation: Silvia Guiu

Printed in China

This book is dedicated to my wife, Adriana, such an endearing woman who brings the color of passion wherever she goes and to my son Diego

I am very grateful to all persons who have participated in this book. I would like to thank all the designers and graphic studios who have collaborated.

Without this persons this projects would not been possible:

-

Adriana Jordan
Antoni Canal
Isabel Lorente
Pamela Santacroce
Sylvie Estrada

-

To all my students from the Instituto Europeo di Design-Barcelona

Brunno Gens

Cati fernandez

Cuarto Piso

Daniel Japiassú "DJ"

Diego Guitton

Gilberto Strunck

Guilherme Dutra " Gaucho"

Handy & Randy Communication

Henrique Guitton

Jaguar Negro

Jeff Fisher

John Wingard

Julia Camargo

Kairos y Cronos Diseño

Leandro Camargo The big"

Marcelo Machado "Chipa"

Myrla Guitton

Renato Japiassú "Japi"

Rodrigo Sampaio "Didi"

Staff Ingenium

Staff Index Book

Stésio Henri Guitton

Teresa Guitton

Tyler Blik

Xigno Comunicación y diseño

INTRODUCTION

I consider myself lucky, because I love my job. My work resembles myself, I live in a constant evolution and thus my most recent creations give me greater satisfaction than my earlier ones.

The most important thing may be to communicate in a simple and original way; this is after all the aim of our work. But the challenge is even greater if we take into account the diversity of opinions, based on individual experiences.

We are constantly looking back in search of references, which helps us to grow. The future however is nothing more than the result of the present. Then, why not bet on the present and live it intensely? The best is yet to come!!!

Logos from North to South America proposes exactly that by giving us an insight into recent trends, the unusual and the different. It has been put together with plenty of creativity and with the aim of breaking away from familiar concepts.

The book has 10 chapters with more than 1,000 logos created by talented designers dictating graphic styles!!

I wish you all good luck and success

Design is culture ;)

Pedro Guitton

MITO

At university, I remember listening to friends and workmates referring to a brand as a product, a service or a company. This is not a bad thing, it is logical because we live in a capitalist world. But all the marketing concepts, all the studies related to the perception of value would be more easily understood if we focused on the obvious, something so obvious that no one sees it. We are a brand.

What's your name? Where were you born? Where have you lived? Do you play sport? What are your hobbies? Are you ambitious? Do you like studying? Do you like working?

The funny thing is you would answer these questions in your own way, but if we asked someone you know how they think you would answer, the results may well be different. This is because people may actually perceive us differently from the way we would like to be perceived.

It is essential to ask ourselves some questions:
How do I want to be perceived in my social and
professional environment? Is that communication
the right one?

The visual aspect and the manner in which you interact
with others are paramount, because an image is worth a
thousand words. Lets take a look at these identity
examples:

Which one of them:

Would you eat something cooked by him/her?
Would you ask for a flat's fee?
Would bet money in a rodeo?
Would you hire as your lawyer?
Would talk about music?

Every professional, wherever he/she works, is a brand.
This new vision enables us to use every marketing
concept to manage our professional career. Thus,
I will know how to improve my professional value,
based on two marketing concepts: the 4 Ps
and the SWOT analysis.

The 4 Ps are the basic features of the marketing mix, namely: product, price, promotion and place.

The product has all the tangible features: the packaging and its characteristics, and design. The price marks whether the product is cheap or expensive, and its status. Distribution determines where the product is sold: store, market… Promotion is every action carried out to promote the product. A successful brand usually has a high perceived value, a strategic distribution and an original support with lots of advertising. In the professional field, the 4 Ps can adapt themselves to the following definitions:

The product (you): personal and professional features, i.e. your studies, work and capacity. The price: that is your value. How much would a company pay for your work?
Distribution: the place where you work, or would like to work.
Promotion: all activity carried out to promote your work within and without your professional environment, eg. Conferences, websites, exhibitions…

The SWOT analysis is a tool used to evaluate the strengths, weaknesses, o pportunities and threats of a brand. This analysis takes into account all the elements from the 4 Ps enriched by the political and economic market scene. The professional analysis is very similar; in order to raise your professional status, you have to promote your strengths, you need discipline to seize the opportunities, and you have to minimize your weakness and try to neutralise the threats.

The difference between weaknesses and threats is simple: if you don't speak Spanish, this is a weakness; but if a company sends you to work in Spain and you don't speak Spanish, then there is risk of bad performance, which is a real threat. The greater your professional status the greater your ability and thus your opportunities.

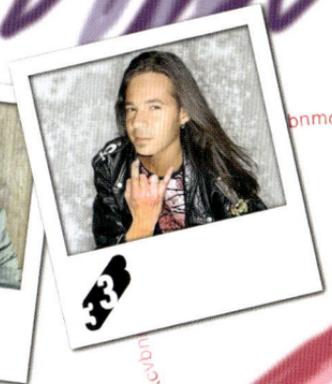

Let's take a look at this example:

Strength (S)
- Leadership
- Persistency
- Objectivity
- Creativity / innovation
- Solid 3D experience

Opportunities (O)
- Learn new things
- Manage employees
- Postgraduate courses
- Better paid
- Invitation for a study group (P4)

Weakness (W)
- Impatience
- Low movement at the company
- Poor network

Threats (T)
- Relation with boss
- Being fired due to downsizing
- Not showing your value at work or company

The great benefit of imagining ourselves as a brand is the objectivity and methodology we gain in order to draw up a self-development plan focused on what really matters and free from any potential emotional blockage. You can start your SWOT analysis by evaluating the present time and enriching it with the factors you would like to achieve in the future. The more transparent the work is, the greater the benefits will be. Verify each month if goals have been achieved. Asking for opinions and receiving feedback is also a good way to enrich oneself and it may help overcome weaknesses. Experience shows us that great career advances are possible thanks to the disciplinary attitude of confronting our profession.

Mirror of the soul

Soul, spirit, heart… many are the names, but probably you would agree that there is something magical in us, beyond what we are made of. Like us, the brand lives. It is born, it grows, and it dies. In our ever more competitive society, companies, products and services have a different personality, with unique features that make them distinguishable among competitors. That personality, formed by what we call values, is the brands' DNA. It has to be up to date in all its manifestations, in every single contact point with its public.
To plan, to build and to maintain that process is what we call branding. The principal aim being the creation of emotional relations with people, so brands can achieve eternal life in the market.
The visual identities are the branding signals of brands. Symbols and logos must express through designs their concepts and values.
When observed, they should recover all the information we have about them instantly. This immense responsibility is what is taken on by graphic designers in these projects.
The brand does not only have to be beautiful, but it also needs soul.

GILBERTO STRUNCK

interagir

MeLT

Mendoza Language Teaching

SOMERSET
CHRISTIAN
COLLEGE

euroamerican
EDUCATIONAL **GROUP**

programme d'animation culturelle

paC

Vasto Mundo

pea

projet étudiants animateurs

ELEVATE ®

KIMBERLY WATERS

TALL
OAKS
CLASSICAL
SCHOOL

ISDAS

Instituto de Sociedades
e Desenvolvimento
Auto-sustentável

ROBERT KENNEDY
CENTRO EDUCATIVO

PIRAQUARA

PREFEITURA MUNICIPAL

Biblioteca
Pública
Estadual

pompeii

Civil Rights Now

Cidadania
nos Bairros

CHAMPS
· PLAY AND LEARN · TUTORING ·

nugss
northern undergraduate
student society

CCPE ⊘ AECI

Centro Cultural Parque de España

Community **Shares**
of Colorado

AMERICAN PACIFIC
UNIVERSITY

frontenac
school
passionate, empowered learning

the
ROYAL & McPHERSON
theatres society

WHO MINDS
THE CHILD?

Who minds the child? Media Education Society
Addressing media's effects on children

ranaschile

MUSEO HISTÓRICO PROVINCIAL
DE ROSARIO DR. JULIO MARC

e·editions

Winnipeg Infertility Resource Centre

Projeto
OUTRA
HISTÓRIA

THROUGH
STRENGTHS
COLORED
GLASSES

GEORGE FOX UNIVERSITY 2002-03

PROGRAMA DE PROTEÇÃO
À BIODIVERSIDADE
E DESENVOLVIMENTO
SUSTENTÁVEL DAS ÁREAS RURAIS

fotosemana
2002

COMUNIDAD ISRAELITA
PUERTO MONTT

fundación
diversidad

PEARSON COLLEGE
NEW HORIZONS CAMPAIGN

umbrales

Bearspaw
Lifestyle
Centre

despertar

Pasto 2004

juegos
nacionales
universitarios

Jóvenes
con empresa

TRASTIENDA

PATOLLI

NAGUALIA
asociación cultural mexicana

NAGUALIA
asociación cultural mexicana

JAMES
JOHN
SCHOOL

MEMA
MISSÃO EIS-ME AQUI

COLÉGIO DE APLICAÇÃO FERNANDO R. DA SILVEIRA
CAP UERJ

icone

revista do curso de desenho industrial da unb # 1

seth donlin, journalist

Facultad de Ingeniería Civil

Región Xalapa - Universidad Veracruzana

Plaza Vista

la jungla

WATTS
prophets

influences

CITIZENS AGAINST LAWSUIT ABUSE

SOFIA SANTIM

EL ROSTRO DE LA SOLEDAD

Full Thesis · Reed College 1999 Bacchanalia

educarium

donde aprendes jugando

HUMAN

RIGHTS

WATCH

uruguaysolidario.org.uy

presentado por fundación acac

HUMAN
RIGHTS
WATCH

HUMAN
RIGHTS
WATCH

CAMP
EDUCAÇÃO E TRABALHO FORMANDO O CIDADÃO

FALL THESIS 2001
A REED ODYSSEY

REED COLLEGE
FA'LL THESIS 2000

EVOLUCIÓN
P Y M E

PROGRAMA INTERNACIONAL PARA EL DESARROLLO
DE PEQUEÑAS Y MEDIANAS EMPRESAS EN PARAGUAY

DAUPHIN COUNTY
VICTIM/WITNESS ASSISTANCE
PROGRAM

**MUSEO
NAHIM
ISAIAS**

SELLO ECOLÓGICO
Ahorro de Energía
UPME 048326

Within the spheres where consequences are not palpable, actions are generated millions of kilometres away and absolutely everybody becomes anonymous. Information sources overflow with the excuse of being multicultural. And what about all those things that represented something at a certain moment in time? Don't the most alien images achieve immediate materialisation? When the human being is not thinking about a method to redesign the symbols codes, when every object is created without a simple and determinate function, all the questions about tradition and use are raised, and the object produced appears as something old and obsolete. But, is there any human being without traces of his/her history? Thinking about rites in a globalised culture instils more of a handicraft and fauvism feeling, rather than the real meaning of having an identity.

Nowadays, as loud colours are re-dimensioned in shapes apparently without any volume, only the presentation of who we want to be without having a conscience, without what it represents nowadays, can get a collective value inside individual parameters of projection. All the simplifications about shape, the reading of actions, attitudes, indications, abbreviation of time and space… all this is melted down into a plane full of harmonic colours, with similarities to homogeneous and neutral layers, where texture and relief become obstacles, because they impede the agility to travel in a space where you have to run, restraining. It's a long way off.

There have always been codes among humans. The human being has always felt the need to say something, although the speech is ever shorter and more precise. The redistribution of the apparent image, urban maps traced on our minds every time we get on the bus, those images that send us specifically to travelling, to our environment and to ourselves. The guidelines need to be valid and recognisable, even for just a moment where by chance we meet with a logo as we turn a corner, or go into a café or a toilet, in an action that unconsciously codifies the mind. Simplified indications of what we come across on any day in our daily lives. The origin of who we are, how we live and what we have become after the beginning.

 JAGUAR NEGRO

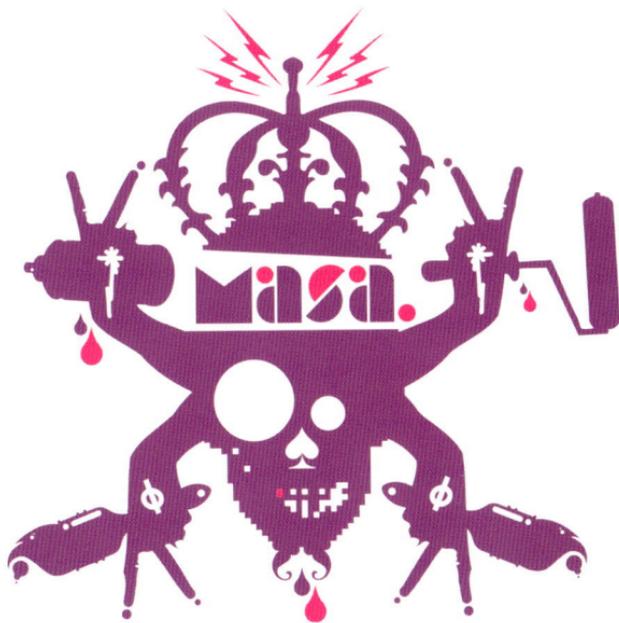

hyenaa

FONTOS
BLOCK

AVENTURA
FOTOGRAFICA

MarioPodestá

DESIERTO de
SOMBRAS

onehugeeye

Fashion
graphie

iD2 COMMUNICATIONS

feandro domínguez

ACTIVE WEB
Web Hosting

mobshot

DRAIN *of* THOUGHT™

my
melodies

w frogmedia

SALLA
comunicação

tríade

ant
comunicação

FASHION
GRAPHIC By
Nohemí
Dicurú Vogel

OCTUBRE GRÁFICO)

greatlogo

uninmueble.com

casa_três_
arquitetura

BIGHOUSE _design_

conceitual
design

ivana ib
barbera

Kosher
Design

El Gráfico

Uh, Chic!

GRAMMA

cats
in the
bag
design

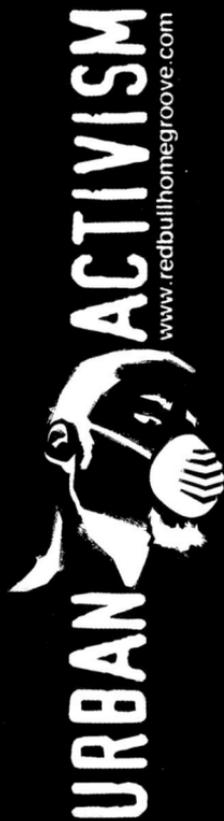

URBAN ACTIVISM

www.redbullhomegroove.com

135 Cats in the Bag Design
Design firm

136 Urban Activism - Red Bull
Urban activism

THE GENESIS GROUP

MANTTIS

DESIGN

GOSSI
DESIGN

abcf
ARQUITECTOS

TM

F O C U S

F I L M

 SERRANO ARQUITECTOS

tridmage®

mediawork®

.neva
diseñadora gráfica

WORK*point*
ARTS
PROJECT
SOCIETY

enzo
G

dek

DEKONSTRUKTED : CREATIVE.LAB

WAVE
COMMUNICATIONS

MOEZART

LEFTHANDSIDE

BALA ®

Juliana Gonzalez

deasil systems INC.

publicidade
e propaganda

CUARTOPISO MDE

fémur

camacho
& asociados

Arts Americas
Latinamerica art gallery

Liana de O. Resende
Arquiteta

MysteryMeat

MikeGillerman

CRABTREE LANE
studio

VISUALORDER

Brainshake.com™

elefante

colaboration

electrofly.com

Bullseye
Design Studios

club
creativa
colombia

a2 • comunicação

GENESIS
design

suzana curi
design

CRISTINA PIMENTEL

arquitetura e design

JANET LITTLE DESIGN & PHOTOGRAPHY

jwd john wingard design

sintornillos
fábrica de ideas

M A R K E T

www.evg3.com

designQuarry

Q3 interactive design®

impactodigital

∋Ӿ DESIGN STUDIOS®
DISEÑO / INNOVACION / DESARROLLO

eyepunch!

wblivesurf.com

Ateliê
de artes

ASOCIACION DE
DISEÑADORES
GRAFICOS

PicturesOfYou
PhotoStock

LESCALA
architect studio

masa crítica

masa crítica

A 4 MANOS

PROYEKTA

decorstand

ELEFANTE · IRLANDES · ANIMATION · FACTORY

TAHINO.

WWW.MASA.COM.VE

DKaL
s e r v i c e s

cooltura®

STEEL

Kairos & Cronos

soluciones integrales de diseño

contacto.01

CAMPAMENTO DE DISEÑO GRAFICO

LOS AMIGOS INVISIBLES
THE VENEZUELAN ZINGA SON VOL.1

DISEÑO **GRÁFICO**

I ♥ MASA

WWW.MASA.COM.VE

VERACCION

cascar
international

aporta

GUANP

BÁTÃO D2 FILMES

LOS AMIGOS INVISIBLES
THE VENEZUELAN ZINGASON VOL.1

What is a logo?

For us, a logo is an entity and an identity: an entity because it is conceived as a shape (graphic, 3D, conceptual) that exists and lives in the world. It is a being that absorbs qualities, expressions, emotions and feelings that make it unique, in other words they identify it.

How can we tell if it is a bad logo?

When it is not capable of communicating the end for which it has been created. When it is not capable of enduring over time, in other words it has not been conceived with enough character to really stand the test of time and falls at the wayside as a victim of fashion. A great example being the "orbititis" experienced and ever-present in the grass roots of the Internet.

How can we tell if it is a good logo?

At school, we were taught that a good logo must be:
- Easy to remember
- Easy to differentiate
- Easy to read

I agree, but there is another crucial factor, and we call it " personality": as well as everyone has their own unique and different features, so should logos. They do not act by themselves, but they are part of a surrounding strategy and a philosophy in which shape is only the reflection.

 CUARTO PISO

La Leche

GRAVISSIMO

cosmopolaris

guía de la noche porteña

zelig

DINKER

mr**bite**
.COM

NITRO
speed & fun

Glory Hills Video
Productions Inc.

3pf

tres
pasos
films

SECUESTRO EXPRESS

jebuke
management

Suplemento joven | Diario La Mañana de Córdoba

LA!MARAÑA
DE CORDOBA

Fiesta de la Cosecha

VERONICA'S POSITION

Festival Internacional
de Cine de Cartagena
cine bajo las estrellas

bocal®

La ENOTECA
CENTRO TEMÁTICO DEL VINO

tiemposviolentos

women in agriculture

ILUS TRA ÇÃO MAGAZINE

Dish magazine

Buttonberry Books

American Film Festival

A TASTE OF INK

pokin
round

RICK'S

PARTY HAT

LA PHIL

LIVING MUSIC

LOSS FOR WORDS

6 ¼

The DREAM STATE

Alaya Star

MODAINC.

oolINC.piadas
de la moda 2005

TRIANGLE PRODUCTIONS!

ELEVENTH SEASON

NAKED
BOYS
SINGING

Sator & Fata

TOM3

CAPRI

MÉLODIE ®

LOUNGE

THE ZONE
NORTE / FILMS

A-DHOK MUSIC

DJS PAREJA

Manston

CHARBEL

SOLO arte

Ms. *Bikini* America™
FIGURE · FASHION · BEAUTY

GIRLS' NIGHT OUT

girlsgotgame

festival
buen día
edición VII www.festivalbuendia.com

festival
buen día
edición VII www.festivalbuendia.com

festival
buen día
edición VII www.festivalbuendia.com

STEREOMATIC

sanojen aika

festival buen día

arriba!

CAUGHT IN THE NET

OREGON FAMILY OUTINGS

grdg3.com MEDIAZINE

Domingo de Lazer

Anne Arundel Green Party

mekate.com

Curly

GUERRILLASECA

X³

TREBLE CLUB

San Diego X California X 2003

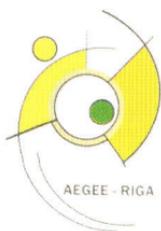

enciende
una luz de justicia

RESMAP

EARTH IMAGE SOURCE

500

OS' ALMIRANTES

ILHA PLAZA
fashion week'2000

CIUDAD CHATARRA MX

Una noche de

paz

La fiesta final.
22 de noviembre de 2003.
Canteras del Parque Rodó.
Montevideo. Uruguay.

Tolerancia, respeto y
diversidad cultural.

ring!

373 Workshop de projetos
Workshop

374 Popa presents
Producer

375 Melhores Mulheres
Event

carnaval
da cidadania
2 0 0 2

TEATRO NOVO

SALA CARMEM
MIRANDA

104.7
universitária fm

Summer Splash
Beach Festival

STONE COLD records

SÃO PAULO FASHION WEEK ■ Vol.04

gratis como el aire

dmente®

02
noviembre
2003

Fly
Bar

GALERA
MIRANTE

Bate Bola
Transpetro

music news.

industria
-VERNACULA

circusmillennia

RECANTO DO NONNO

ESPAÇO DE FESTAS

Maryland Green Party

www.mdgreens.org

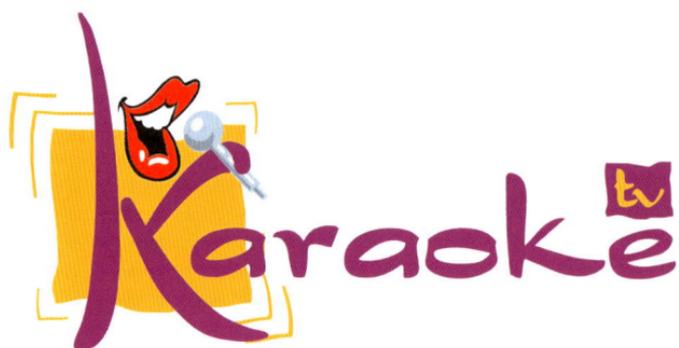

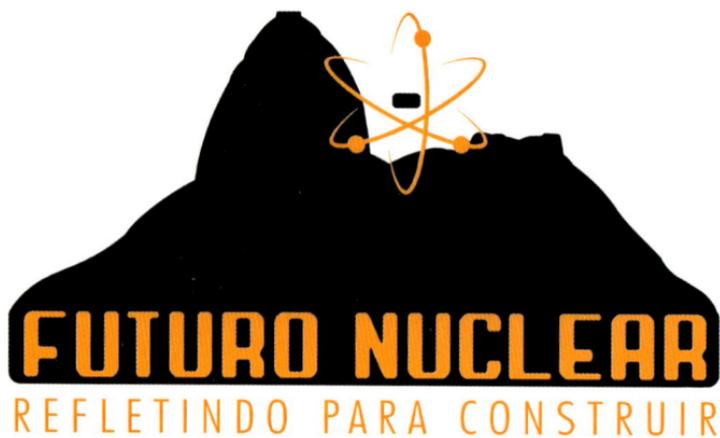

FUTURO NUCLEAR

REFLETINDO PARA CONSTRUIR

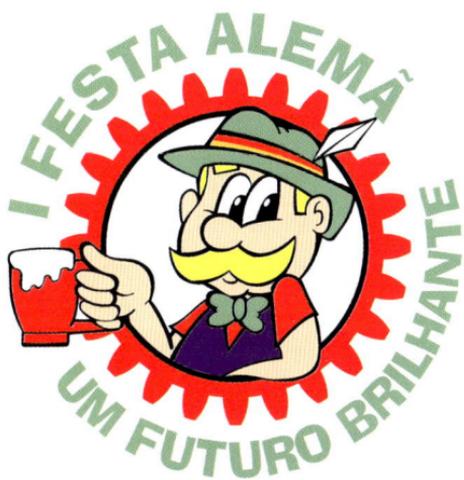

I FESTA ALEMÃ
UM FUTURO BRILHANTE

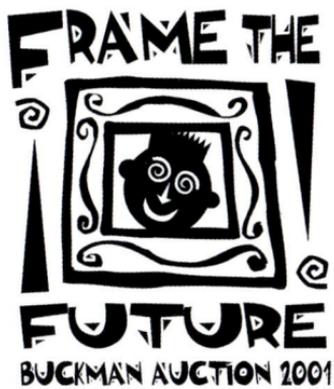

FRAME THE FUTURE
BUCKMAN AUCTION 2001

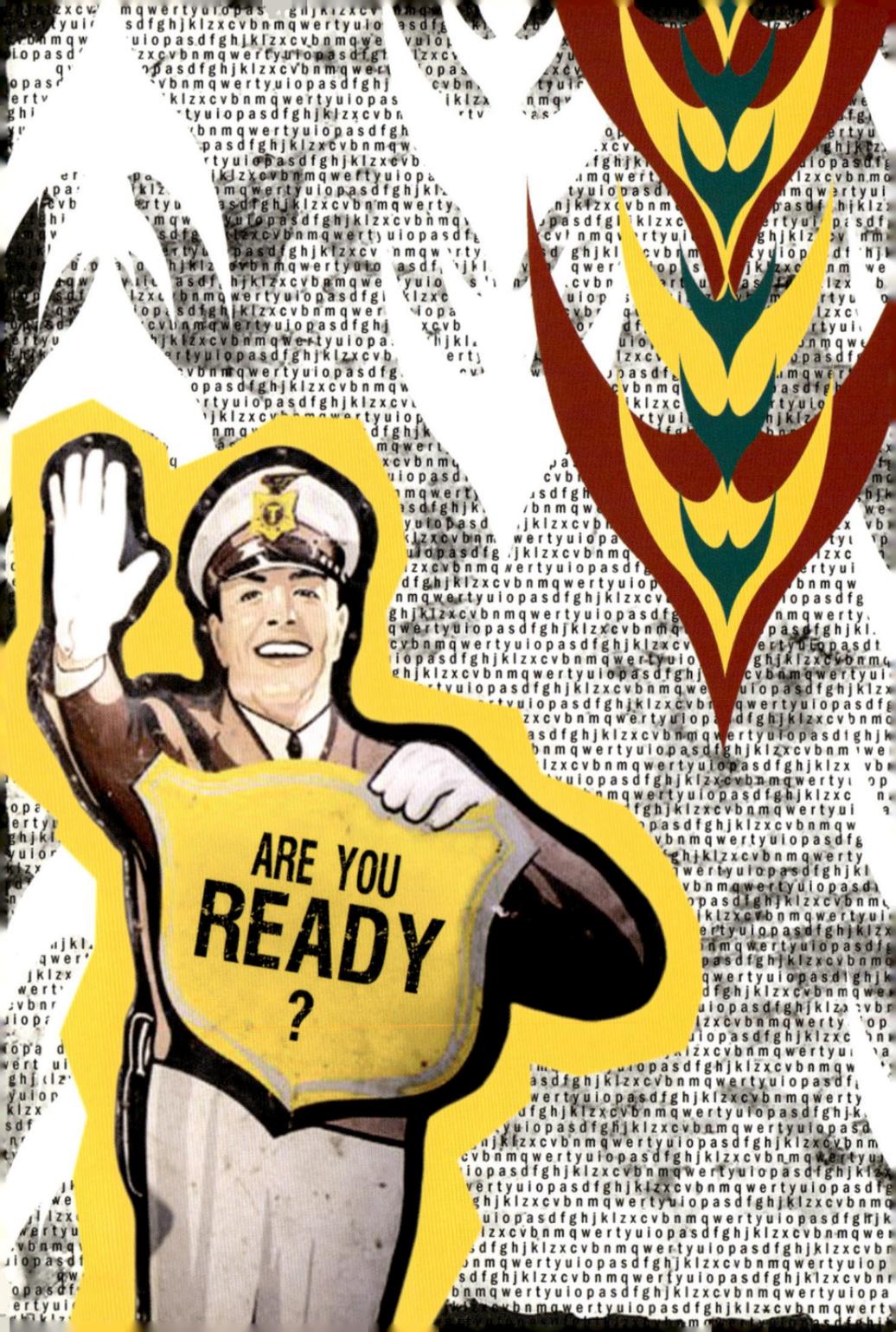

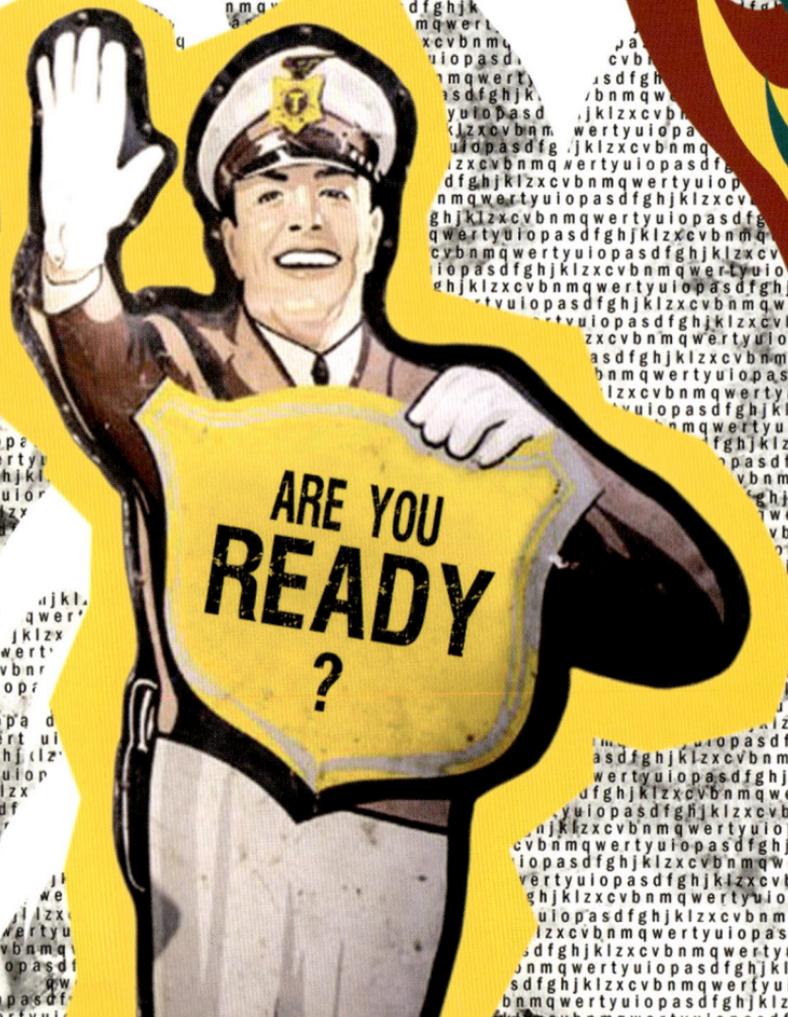

ARE YOU
READY
?

The logo is a combination of graphics and text whereby people can identity and relate to our business. It is considered an independent element, that cannot be rigidly defined, but we do course respect its trend, which can evolve over time.

What is a logo?
It is the element with which every organisation is identified.

How can we tell if it is a bad logo?
We know a logo doesn't work when it does not achieve the function of relating to the organisation, or if the concept is not in harmony with the general idea of the project.

How can we tell if it is a good logo?
We know a logo will work when its presence alone, communicates a general idea of what is being said about the company or organisation. It must be clear and legible.

SERGIO FIGUEROA

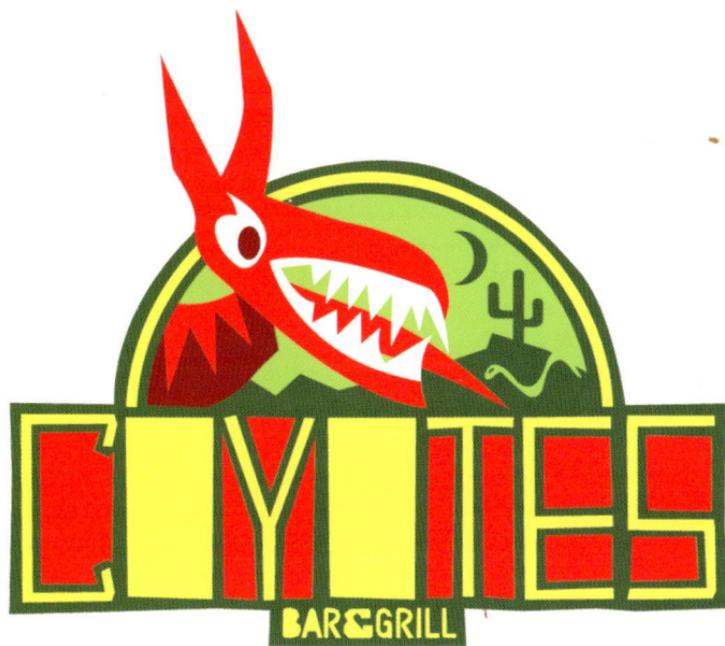

energy poison
ENERGY DRINK

energy poison
ENERGY DRINK

CAUQUEN
SABOR NATURAL DEL SU

Doña Antonia
BOCADITOS DE SOJA

HOT
GOURMET COCOA
coffee · tea · cocoa

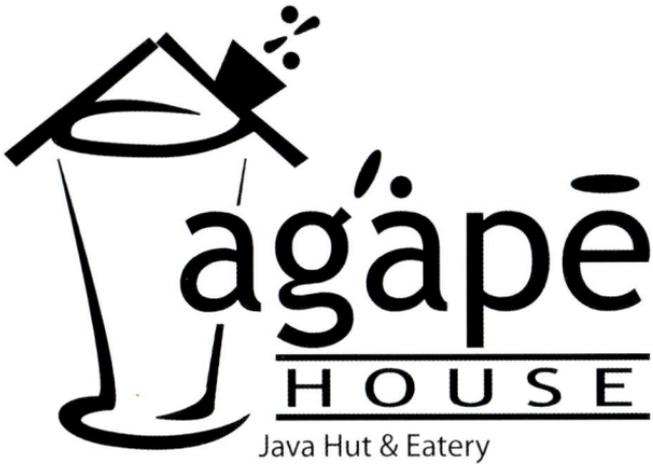

agápē
HOUSE
Java Hut & Eatery

FEVER

¡nueva!
ensalada
césar

degraus pizzaria

BARBATANA

IN HOUSE
CAFFÉ

Yauquen

Productos Regionales

Clube da Empada

PUEBLO ™

Premium Wines & Spirits

HOTCHKISS
HERBS & PRODUCE

GABRIELLI
— BODEGAS Y VIÑEDOS S.A. —

GoldenFruits

Repostería de la Mamá

twin dogs®

eko

LORCA
CAFÉ

Mozart
CAFÉ & EVENTOS

Cacao
todo en chocolate

RESTAURANTE
AUSUBO
PUERTO RICO

VANCO
FARMS LTD.

Cacao
&
todo en chocolate
Café

CALAC

SANTUCCI

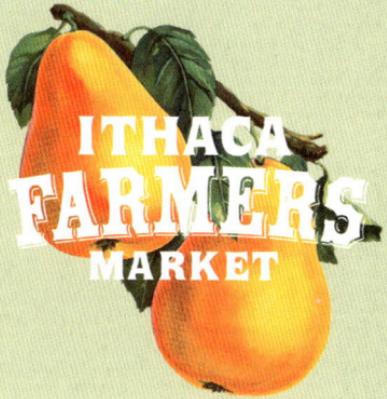

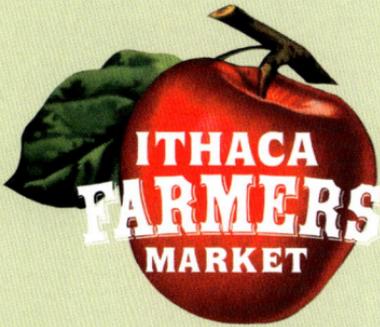

444 - 446 Ithaca Farmer's market
Community farmer's market

Too O Much
Restaurante

Mr. Fluffy

PALATUM
comida & botequim

For Your Paws Only

JAVA
coffee house

Raymunda and Severyna

GORBY'Z
Bar Grill

SOL DE LOS ANDES

VidiVINO

vientoverde

MERCADO ECOLOGICO

gaia

SaNta
Saideira

CAZA MAYOR
CARNES

Ernesto's Espresso

Espresso&Co.®
Café • Frappes • Té

TAZAS
Y
TARROS
CAFE • BAR

TOMATO

La Mexicana
¡Me encanta!®

The Real Estate Cafe

KAO THAI
RESTAURANT

PINKY'S
PUPU BAR & GRILL

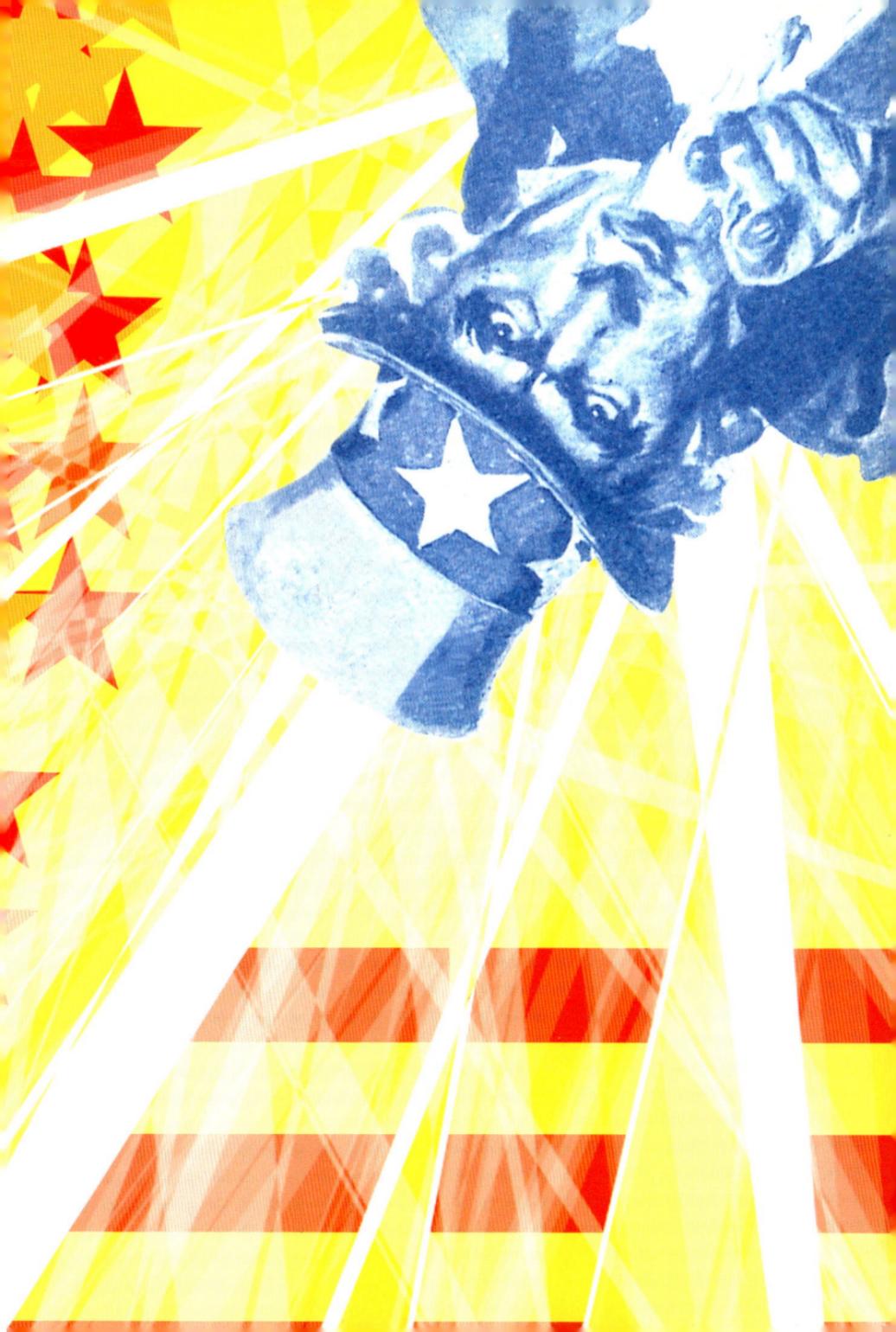

Think big, be simple. At a time when within everyone's life there is too many gadgets, too much traffic and a multitude of information that we receive day to day, it becomes more and more difficult to gain attention with one's identity. Whether a global Fortune 500 company or an individual doing business from the internet, a business or organization's identity should be pure and simple. It should distil the essence of what your company's product(s) or service(s) says to your audience(s). Your identity should represent the spirit of who you are as a company. An identity or logo can never say everything about who you are as a company. There are many other marketing assets of a business or organization that provide that opportunity. An identity is the signature of your company from which all information and promotion is built around. Much like an individual's signature an identity is unique, but all the while providing a vernacular that is easily recognisable to your audience(s). A business' identity is the driving force and distinctive endorsement of the values you share with your customer.

The most successful identities are simple, expressing the core values of your business. Smart logos have a double meaning or a hidden message. Not everyone sees the arrow in the negative space of the FedEx logo between the 'E' and the 'x'. A successful identity does not assume the obvious. Remember, your identity is more than just factual information. A successful identity looks for creative ways in which to express its product or service. Should an identity be strong and forceful Or, should it be delicate and peaceful Should it be bright Should it be traditional, or should it be contemporary An identity should parallel your company or organization's overall objectives and those with whom you want to reach.

The best identities gain a customer's trust through their clean, direct and positive perceptions, continually leaving

them with a memory of who you are and what you represent to their psyche.

 TYLER BLIK

atmosphere

SIOMARA

Firenze

Maimará
diseños nativos

Acenorca

VISTA HOUSE
EST. 1918
RESTORE THE JEWEL AT CROWN POINT

FLAMBOYANT
RESIDENCIAL

WESTGROUP
SOLUTIONS

38|SPECIAL
EXTREME CLOTHING

HEART
OF THE
PEARL

N.W. TENTH AVENUE
N.W. DAVIS STREET
N.W. EVERETT STREET
N.W. NINTH AVENUE

Kay Johnson's
Sing Out
PRODUCTIONS

gesa
GESTION Y ESTRATEGIA AMBIENTAL

HEIDLER ROOFING

R.D. Arnold
creative remodeling

I WANT TO™
BELIEVE

CASA DOS
PARAFUSOS

SANFORD®

DERING

Out of Thyme
CLASSIC CATERING & EVENT DESIGN

ONIT

betabel

ALLIANCE LIGHTING

EC PROMOTIONS

fahari

de Francy Sanchez

camawe

industria e comércio de móveis LTDA

mosaic

M A R K E T

PAIN
Leather & Novelties

Indy
PARK & SELL
SINCE 2003

NOT QUITE AN ANGEL

I ♥ MASA

I WANT TO™
BELIEVE

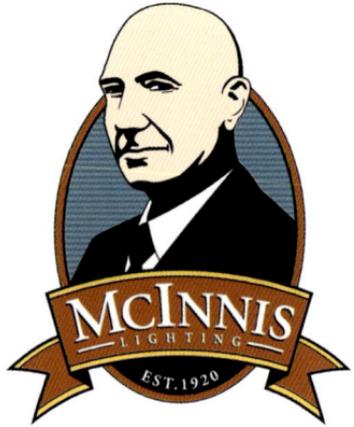

McINNIS
LIGHTING
EST. 1920

xeo

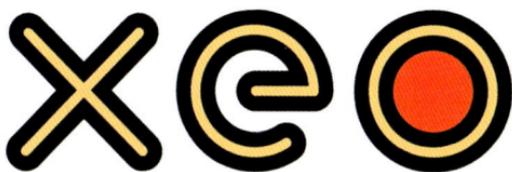

Xeo International

VIISTA

volconvo

Radloff

Fulltrack

MOVIL

writing &
editing services
discerningwords

INSTANTICKET
espectaculos sin limites

MacNeil Financial
& Insurance Brokerage Corp.

Yeris Paola

Guasabi
Furniture company

KNOWLEDGE ENERGY YIELD

ARGENTINA CROSSING S.A.
CONSULTORES FINANCIEROS

ilméx

lucuma
OriginalDesigns

3DLꝈRIDILUCK®
THE CLOTHING LABORATORY

DUCK
Outfitters

COMPUTER
CENTRE
SERVICES

OCA

MARINA LYRA

ONLY
FOR
GiRL™

OLDskooI

Board Shop

circuit express

VI✖EN

Simulacro E.

STONE

GROUP

ARTE FEITO À MÃO
feira hippie de ipanema

Hush
Puppies

feijão bola oito

MTH
Tecnología del Frío

MANOS A LA OBRA

tarjeta empresarial

M E T H O D

wett

3mg®

Victória

BABY e KIDS

SMART
TOYS
Inc

GIRL CANDY SHOP
INC.

VIII **FORO** INTERAMERICANO
DE LA MICROEMPRESA
SANTA CRUZ, BOLIVIA

ABSECON CANADA

Grade A Fabrics

Queen's Printer

Babies.

Gidget ®

StOLZ

Burial Fund

Christian Immigration Society

airdocs

NEW ENGLAND FIREWOOD COMPANY

cyberspun

BANCO·DE
BOSTON

iris reader

CollinsSimms

Polyglot
Press

Colony
Savings Bank

BURÓ
RASO
MOBILIARIO

FLORES DO
Éden

Arranjos com estilo.

welove Alberta.com Inc.

sea quest
CLOTHING MANUFACTURING CO.

BENTLEY
CONSTRUCTORS

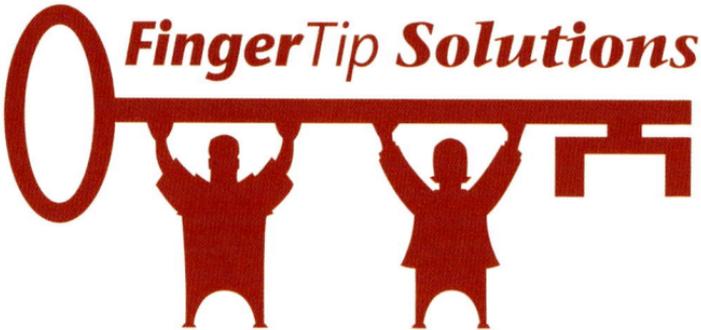
FingerTip Solutions

MARÍA CAMILA MESA®

ACCESORIOS

SOLO
UNO

ZAMURA
INCORPORATED

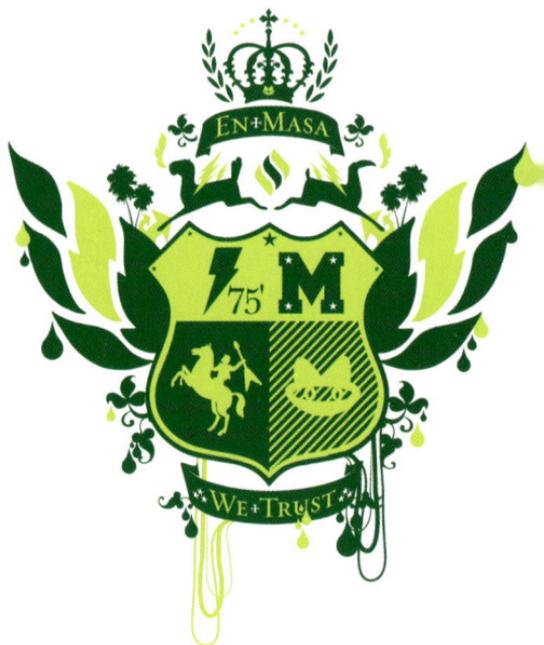

quirogaquiroga

ropa de lana

general contractor

Harrison Flowers

vitraux

BLEU

LIGHTING DESIGN

Salsa Brava

Arte Nativa:

kos
ACRÍLICOS

3ISTERS
PROPERTIES

BALLOONS
ON BROADWAY

cuisipro

EN MASA WE TRUST
WWW.MASA.COM.VE

González
A L U M I N I O S

SECONFYA
Servicios de Contabilidad, Asesoría Fiscal y Auditoría.

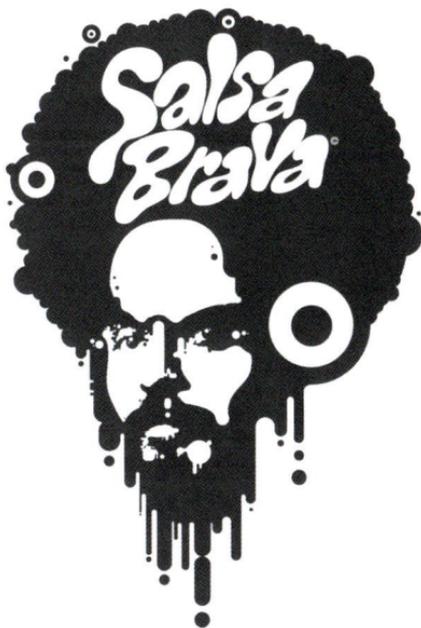

OnA®
leisure + sleep + underwear

(skæn)®

Sterzer
STERZER & Cia S.R.L.

ROOM®
ELEVEN11
ARE YOU IN?

CERÂMICA
OURINHOS

morlees

ONEIGHTEEN

1
1
8

Borboleta
Flores

Pring
Álcool Spray

F&G editores

Aniversario
10
F&G

POWER UP Alabama

WAIDROKA
ESTATES

vinntage

tekArtison

GRUAS
DIAZ

We believe all brands have and give value. The fun part is making the brand, and of course, giving it it's desired or necessary value(s), in an original and unique way. A brand must have itís own identity, if not, It could be mistaken for another one, considered plagiarism or cause little impact. The value of branding moves the world. We live in a society of massive consumerism, which is fueled by the power of brands, therefore, we believe, our world would simply become chaotic without it. Commerce depends on it, and we, as Art Directors live it everyday, and we donít mean to sound as if itís all that matters, in that sense, because branding expands in all fields, even non commercial and experimental. For instance, branding is in all art forms sculpture, painting, architecture, etc... The artist creates a style, method or technique. It then turns into something people recognize and refer to; Itís called branding.

REVOLVER DESIGN

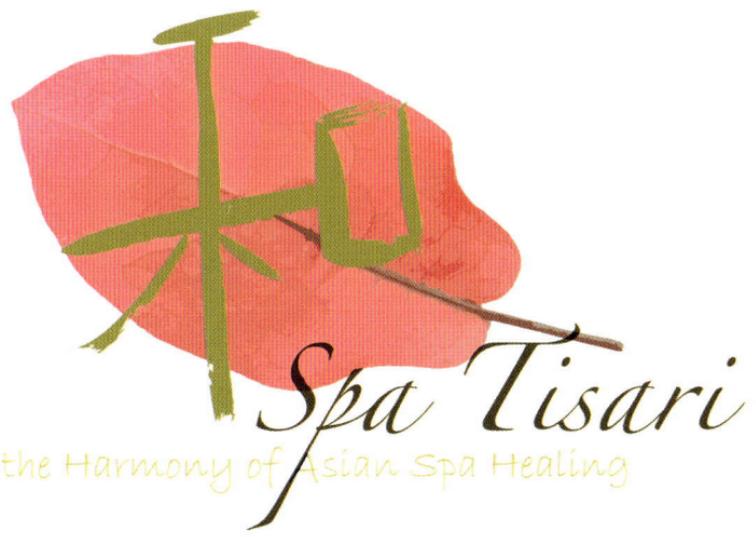

Spa Tisari

the Harmony of Asian Spa Healing

Dental*express*
Centro Odontológico

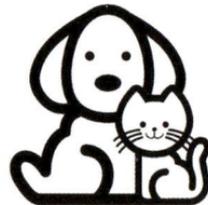

dr. resburgo
CLINICA VETERINARIA

HECA
Hospital de Emergencias Dr. Clemente Álvarez

DERMANOVA
CREMA PARA ESTRÍAS

dermanova
CREMA PARA ESTRÍAS

GOOD
SOAP STUDIO

emergencias veterinarias

quanyin
paz • armonia

VANCOUVER
ISLAND
prostate
cancer
RESEARCH
FOUNDATION

PLANO
Vida
Light

PRODUCTOS

TITIKAKA

gou

Gerard

smile INNOVATIONS

 CETAO

A RUBBER'S DUCKY

CLÍNICAS
INTEGRADAS

Vida
Saúde

SEACOAST ★

★ AIDS WALK

"pardon my french"

LUXE

SALON & SPA

Centro de
Reprodução
Humana
Genética a serviço da emoção

Francisca Guzmán
Phycology consulting

seeyou

Breezy Garden

DIF

DESARROLLO E
INDUSTRIALIZACION
FARMACEUTICA

Altamira
CLINICA VETERINARIA

Quirón
bibliografía médica
inglés-español

RETROSPECS
VINTAGE EYEGLASS CO.

SUNAROMA

Virginia Eyecare Center

Microbiológica

PROGRAMA DE
INTEGRAÇÃO

Houston Oral Surgery Associates

Diva

Classic Style for Hair and Nails

HOSPICE OF

HUMBOLDT

Image is a reality.

A logo must be both clear and distinctive while communicating the unique position of a brand to the target audience. It must then be applied consistently within environments that are relevant and meaningful to that audience.

 JOHN WINGARD

Zenergy
yoga studio

DRIVING
NORTE

Contra corriente
Red Bull®

Bólidos Drivers
CURSOS DE CONDUCCIÓN RED BULL

CIRCUITO NACIONAL DE SURF

**Corrida
Internacional
de Natal**

Corrida da
Primavera
Homenagem ao Aniversário
da Ilha do Governador

Circuito Carioca de corrida

directorat des sports

CRESCENT SPUR
HELI·SKIING

BICIACCIÓN

BLUE MARINE ®
TECHNOLOGY
OFFSHORE SERVICES

COPA
FILIGRANA
2 0 0 2

Concejo de Danza de Bogotá

FUTBOL
DE PRIMERA

SUMMERSIDE
SPORT & CYCLE

le camp
d'entraînement

EUROKART
Outdoor Racing Challenge ®
BAJA • MEXICO

61º CONGRESO MUNDIAL
DE LA PRENSA DEPORTIVA
AIPS World Congress
Abril 1998 - Montevideo - Uruguay

MCBIKE TRAILBOMBERS.com

H2O

équipe
manitoba

eye51ve

SaltSinker

LATIN®
CONQUEST

Boxe

THE OAKS
AT
PALA MESA

RockSolid
SURF TECHNOLOGIES

ROCK SOLID
SURF TECHNOLOGIES

Oregon Adult Soccer Association

MET-Rx™ PRESENTS

NAVY
FITNESS CHALLENGE

Forever Young
Fitness

LAKE ELSINORE
SPLASH

HUAIRASINCHI
COMPETENCIA DE AVENTURA

5K

Run for Faithful Friends

gamers hell®

Fair Play

SENSILASER

LASER
FISH

coup fourré

THUNDER

More than an eye catcher, a logo is a cultural product, therefore conveying the preceding tradition and linking with the culture where is immersed. That is the very challenge for us, designers: to create a product that is culturally appropriate.

To achieve that goal, the client is deeply involved in the development of a brand. The organization goes through a process of self-discovery that enables: the identification of which are its differential values, which cultural ingredients benefit the customer/end user and whose strengths are not yet utilized.
Is up to the designers to conceptualize an image that represents, in a unique manner, these identity cues.

When a logo roots within a culture has more survival possibilities because
is nurtured by its elements and interacts with the past, projecting itself to the future.

KAIROS Y CRONOS

econveyance™
by RemoteLaw

CONEXIÓN
YAHOO!
ARGENTINA

Y2K.
suplemento de informática y tecnología

cognitech

color
dpi

bcrstn

The British Columbia Regional
Science & Technology Network

CL
CRISTALAB

CRISTA**LAB**
macromedia certified
FLASH MX DEVELOPER

OpenQue

COGNEVA

NetPos

Sistema de Gestión Retail

NetWms

Sistema de Gestión de Bodegas

NetCar

Sistema de Gestión Automotriz

NetFin

Sistema de Gestión Financiera

UNIFIED
systems group

nrg
:: stream
POWER MARKET MONITORING SERVICE

esquared
GROUP

Business Intelligence
Forge Corp.

HORTUS

DIGITAL

middle digital inc.

TOTAL
GROUND
ENERGY & PROTECTION SYSTEM

VALUES-BASED
BUSINESS
NETWORK

SOPORTE
& CIA. LTDA.

archaea

ceti
centro de estudios
en tecnologías de
la información

b-Orbital
e - COMMUNICATIONS

SuperTown™

Supertown
IT trade show and conference

LensSeeker
.com

lausnova

Sistemas y Consultoría

innovate101
BUILDING THE FUTURE TODAY

Technology Management Corporation

TMC **products**

TMC **consulting**

TMC **tech**

TMC **visionpool**

:: brand management :: interactive solutions :: digital marketing ::

HARRY
KRANTZ
COMPANY

ALLMEDIA

FASTMAIL

luminet
SYSTEMS GROUP

intermark® solutions

IMOB SYSTEM

Phonetics

Copy Símile
REPRODUÇÕES GRÁFICAS

contegra
SYSTEMS

f
FERENTIAL

WCI
**WHYTE
COMMUNICATIONS
INC.**

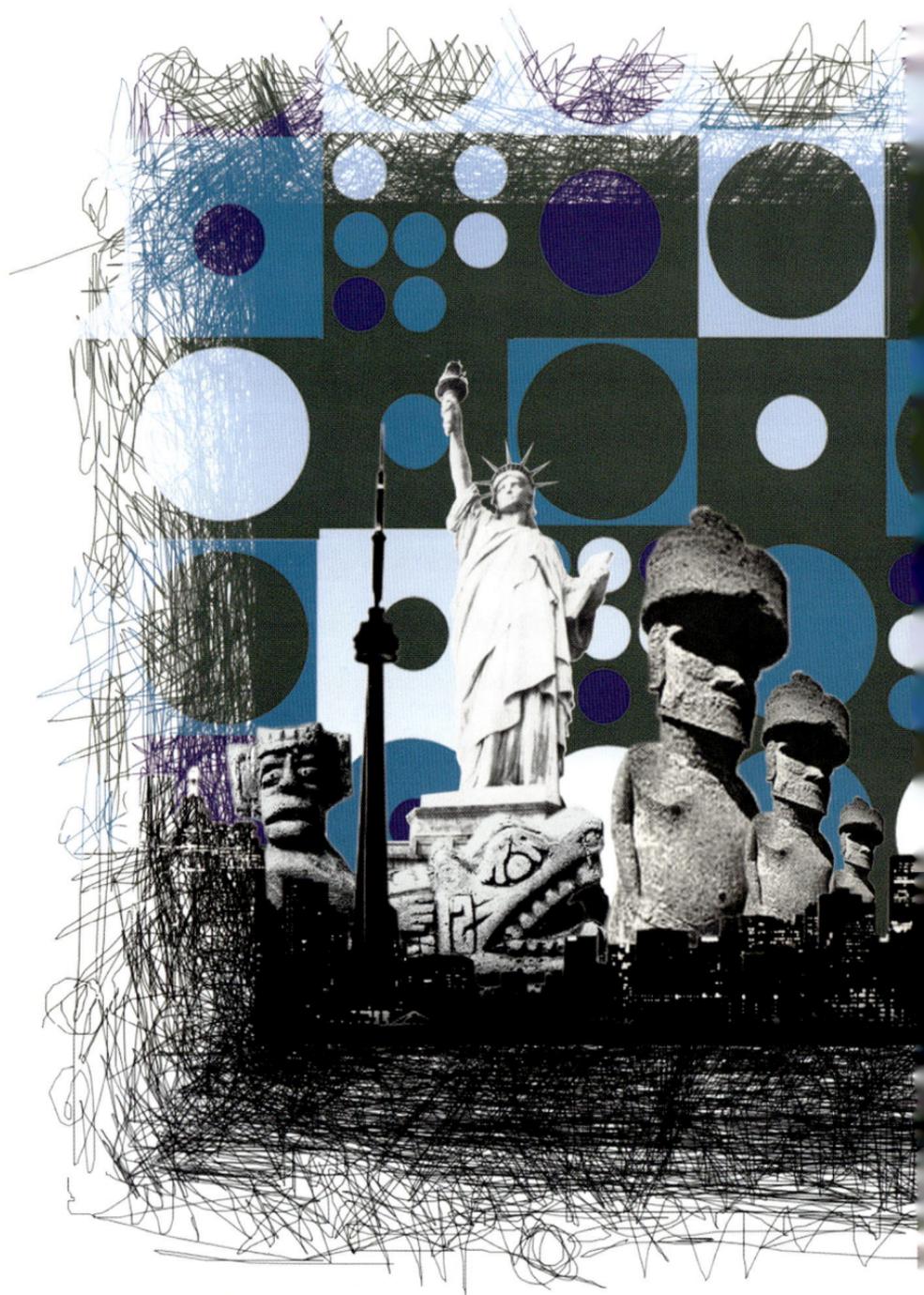

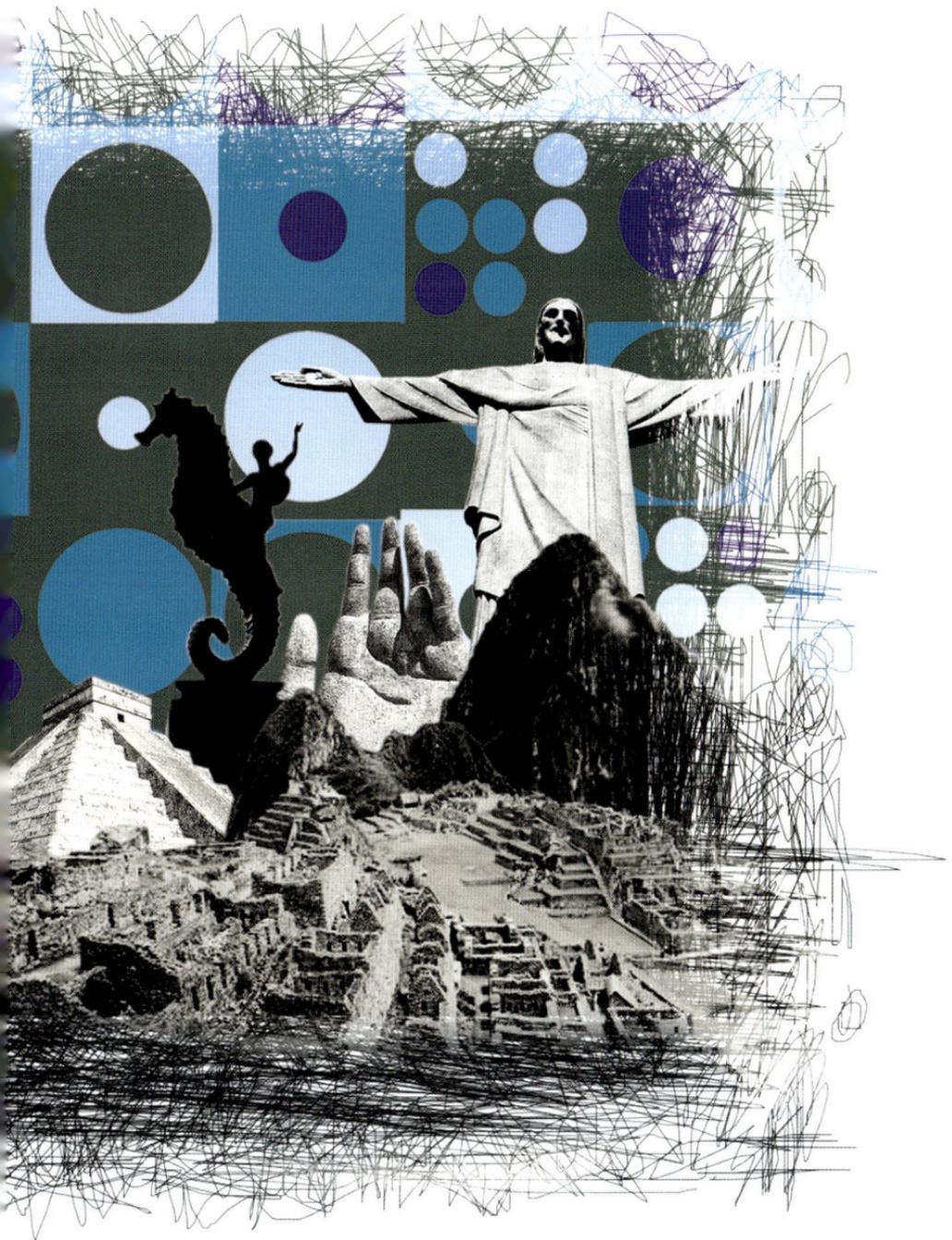

A logo is the minimal graphic representation of the essence of
a brand or corporation.
What makes a good logo?
Simplicity it´s important considerate a marketing strategy, First
because you will see what thinkthe market, how to behave with
the product or service. And second, because you´ll know where
and how the people are going to see the logo.
Keep a very close communication with your clients.

 XIGNO

waterfalls

HACIENDA
DEL MAR

estilo turista

COLONÍA
ÐL SACRAMENTO

LAGUNA
DE LA NIÑA ENCANTADA

PHILIPS
PARADOR PINAMAR

LaMandarina
Pousada e Pizzaria

10-PIN
MGM MIRAGE
CLASSIC

CALLIANDRA
pousada e pizzaria

Hacienda Ojo de Agua

Costa Rica

AZIMUTH

AEROLINEAS ARGENTINAS

Hotmap

RIGA CITY HOSTELS

QUITO
Distrito Metropolitano

falcon
trails
resort

falcon
ridge
ski & recreation
area

RiverwoodPark

RiverwoodPark
campground

FALCON BEACH RANCH

HOTEL
NIVENTUS
CADENA HOTELERA RECREATUR

847 Martin Torrijos
Presidential campaing

TravelMole

u y u n i
desierto blanco, lagunas de color

mgf TRAVEL

MANHATTANDALE'S

Rincón Sur
POSADA

MGM GRAND
SUPERPARTY
XXXVII

DreamStream
.com

Parque ecológico acuario
ISLA PALMA
COLOMBIA

TIERRA VERDE

AIR CANADA ✱

*en*Route

YOUR COMPLIMENTARY IN-FLIGHT MAGAZINE · VOTRE REVUE DE BORD GRATUITE · FEBRUARY · FÉVRIER 1998

turismo aéreo®

COMERCIALIZADORAVACACIONAL

PANAMANIA®

Logo design has been a passion since I was a teenager. Attempting to graphically convey as much information as possible about a business, organization or event with the simplest of elements and/or type is always an exciting challenge. In my own work, playing with letterforms, manipulating graphic images, or combining the two uniquely to establish an effective identity involves research, strategy, art, design, a dose of theatre, playfulness, a bit of cleverness, a pinch of engineering, some understanding of business marketing, knowledge of advertising principles, and many other recipe ingredients. I enjoy visually teasing, or daring, the viewer to take a second look at a logo and see what they can find within the design.

I get a great deal of personal satisfaction when an unsuspected "brain fart" - usually when in the shower, driving my car, gardening, sleeping or doing something else unrelated to design - suddenly presents the solution to a client's business identity crisis. That "a-ha!" moment makes any frustration, or struggle, in the context of the concept development for a project very worthwhile. Occasionally I create one design, and present it as an only option to the client, knowing it is Thedesign to represent their company or organization. In about 80-85% identity projects the final logo for a client evolves from my initial concept.

 JEFF FISHER

la**vida**es**sueño**
CASA PRODUCTORA

Tierra.

PUMA
Protección y Uso Sostenible
del Medio Ambiente

N L S
NATURAL **LIFT** SYSTEMS

ALBERTA HOUSING COALITION

CRIA2003

CONGRESO
PARA CRIADORES Y TECNICOS

invento
argentino

PROYECTO PEYU
tortugas marinas en argentina

HR
WATCH

ELSEWHERE

Vitória da Vida

ARFIC

PSYCHOMETRICS
PUBLISHING

terapia intensiva para cessação do tabagismo

CONSULTORIA
Aprendizado Cultura Gestão

ACES
Alberta Corporate Event Services Ltd.

S E E T A

CREART

CARWASH

2000 Corp.
IBEX

BIG DADDY
ADVERTISING SPECIALTIES

CÍRCULO DE AMIGOS DO MENOR PATRULHEIRO
C.A.M.P.
PIERO POLLONE
Desde 1976

a AMERICANINO®
KEEP MOVING

QUERCUS
Landscape Construction Ltd.

Programa de Descentralización y Modernización
Municipalidad de Rosario

Distrito Norte

Distrito Noroeste

Distrito Oeste

Distrito Suroeste

Distrito Sur

Distrito Centro

chullalata
f i l m s

EMEX

GLOBAL
MANAGEMENT
C o n s u l t i n g
■ CONSULTORES EN GERENCIA

possibilities
network inc

Rosario Suma

Parque Yrigoyen

Centro de Iniciación Deportiva

Escuela de Artes y Oficios

Rosario Suma

FUNDACIÓN ARGOS

PATRIMONIO CULTURAL SUMERGIDO

centercom

GEO**ENERGY**
consulting and services ltda.

AZIMUTH
CAPITAL MANAGEMENT LLC

CAPULETO boys
since 1998

allusion

908 Capuleto boys
Production company

909 Allusion
Towel logo

910 3 Malandros films
Production & film company

BullsEye

environmental

GEO

técnica

HANS SIEGEL
& ASOCIADOS

cut to the chase
PRODUCTIONS

el Tibar

diseño para vivir

AZIMUTH

CAPITAL MANAGEMENT LLC

GEOCONSULT

niñoesperanza

Encuentro
Latinoamericano
de
estudiantes
de
Historia

Núcleo de Corporeidade e Lazer

Pro-Creadores A.C.

Best on Request Inc.

WaterCo ®

THE WISHART MEMORIAL FOUNDATION

DUTCH and QUAIL
VITALIZER TREATMENT

Lyo Life

INTERNATIONAL

CARMEN LEÃO
CONSULTORIA IMOBILIÁRIA

nPoint

Amigos do Rio

GAVILAN

nueva pizza ligera

¡super delgada!

INTEGRITYPLUS
Financial Inc.

Aeropuerto Internacional de Quito

EDMONTON MENNONITE
centre *for*
newcomers

planet one®

MULTIPLUS 9 13

LP Landscaping

RuaNova
Agencia Aduanal®

Consenso

CleanGuard LLC

Liz Garratt

www.lizgarratt.ca

CACO
PEREIRA

ASSESSORIA GASTRONÔMICA

DESIGNS

CANADA

948 Argentinos Sobreviviendo
Non profit organization

WISCONSIN HUNGER

Wildcat

midwiferycare
PARTNERS

TRANS
TUR

GM RACING

main street
papery

Shock modeling ®

DEFENSE
PHOTONICS
GROUP

i.hear
unicare *inc.*

PENINSULA CLEAN TEAM

RED HAT

micro-winery

Coyner's AUTO BODY, INC.

SINCE 1976

MOTORVAC
CarbonClean
SYSTEM

LOFT417

VALLES
CALDERA
NATIONAL PRESERVE

TRAN'ZIP®

global delivery

womenbuildingfutures

pleasantHILL

Sumitemp

Forgotten Children of Honduras

NORTH PORTLAND · BUSINESS ASSOCIATION ·

QUEM CALA CONSENTE · DENUNCIE A EXPLORAÇÃO SEXUAL DE CRIANÇA E ADOLESCENTE

tecnomercado.com

ciencia tecnología y negocios

outsourcing laboral

FUNDACION

PAISSEGURO

Chat

b&m
marketing

{digital **MEDIA** UNLIMITED}

wellpressed

The Flea Market

alive water

Estância Flórida

SVS GROUP LLP
CHARTERED ACCOUNTANTS

LAS BRISAS, AMADOR
· Isla Perico ·

empletemp

PersoTEMP

Big Creek
VILLAGE

arboreto
PAISAGISMO

bacutia

JARDINAGEM

Mr. Dog®

PetShop

INDEX BY NUMBER

50 Ramiro Viveros Calle -Colombia
51 Ruben Bonder Rabinovich - Chile
52 Versus Comunicación -
 Peter Mussfeldt - Ecuador
53 Ramiro Viveros Calle - Colombia
54 SmashLAB - Eric Karjaluoto - Canada
55 Trama diseño - Rómulo
 Moya Peralta - Ecuador
56 Versus Comunicación -
 Racel Jaramillo - Ecuador
57 Handy & Randy
 Communication Inc. - Canada
58 Catalina Estrada - Colombia
59 Ramiro Viveros Calle - Colombia
60 Juan Torneros - Colombia
61 Pablo Daniel Correa design - Argentina
62 Disforia design -
 Luis Eduardo Iturra Muñoz - Chile
63 Carlos Riveroll - USA
64 Carlos Riveroll - USA
65 Carlos Riveroll - USA
66 Jeff Fisher - USA
67 Cleber Gossi - Brazil
68 Diogo de Barros Bonaparte
 and Isabela Salino - Brazil
69 Ben Miller - USA
70 Suzana Curi - Brazil
71 Elle Steiner - Brazil
72 The Jaguar Negro Group -
 Argentina and Mexico
73 Graphik illusions image architects -
 Alison Isadora Vallocchia - USA
74 Masa Crítica design - México
75 Christa Defilippo - USA
76 Opacityzero - Christine Pillsbury - USA
77 Jerry King Musse - USA
78 Azul de Corso - Argentina
79 Jerry King Musse - USA
80 Revolver Design - Ricky Salterio - Panama
81 Jeff Fisher - USA
82 Masa Crítica design - México
83 Chad Upham - USA
84 Kairos & Cronos design -
 Alvaro Heinzen - Uruguay
85 Chad Upham - USA
86 Jeff Fisher - USA
87 Carlos Riveroll -USA
88 Rodrigo Machado -Brazil
89 Jeff Fisher - USA
90 Jeff Fisher - USA
91 Juan Torneros - Colombia
92 Juan Torneros - Colombia
93 Juan Torneros - Colombia
94 Juan Torneros - Colombia
95 Juan Torneros - Colombia
96 Juan Torneros - Colombia
97 Coeficiente - Hugo Lafuente - Paraguay
98 Jerry King Musse - USA
99 Ramiro Viveros Calle - Colombia
100 Versus Comunicación -
 Peter Mussfeldt - Ecuador
101 Masa Crítica design - Venezuela

102 Disforia design -
 Luis Eduardo Iturra Muñoz - Chile
103 João Guitton - Brazil
104 Patricio Oliver - Argentina
105 Cinthia Cabero Mencia - Argentina
106 Pablo Daniel Correa design - Argentina
107 Pablo Daniel Correa design - Argentina
108 Pablo Daniel Correa design - Argentina
109 Alex Amelines - Colombia
110 Nohemí Dicurú - USA
111 iD2 Communications Inc. - Canada
112 Patricio Oliver - Argentina
113 Rafael Castaño design - Argentina
114 Cinthia Cabero Mencia - Argentina
115 Alex Amelines - Colombia
116 Patricio Oliver - Argentina
117 Frogstudio - Florencia Sadous - Argentina
118 Carlos Riveroll -USA
119 Tiago Brito Santana - Brazil
120 Waldomiro de Mello Moraes N eto - Brazil
121 Luciano do Monte Ribas - Brazil
122 Nohemí Dicurú - Venezuela
123 Juan Torneros - Colombia
124 The Jaguar Negro Group -
 Argentina and Mexico
125 Ali Dib - Canada
126 Rafael Castaño design - Argentina
127 Sandra Torres - Brazil
128 Ben Miller - USA
129 Fabio da Mata Neves - Brazil
130 Nohemí Dicurú - USA
131 Ruben Bonder Rabinovich - Chile
132 Mauricio E. Lopez - Argentina
133 Patricio Oliver - Argentina
134 Nohemí Dicurú - USA
135 Cats in the Bag Design -
 Jennifer Cook - Canada
136 Pablo Daniel Correa design - Argentina
137 Ben Miller - USA
138 Carlos Alberto Narváez - Colombia
139 Laura Karina de Amorim - Brazil
140 Versus Comunicación -
 Peter Mussfeldt - Ecuador
141 Frank França Volkmer - Brazil
142 Cleber Gossi - Brazil
143 Tyler Galli - Canada
144 Nohemí Dicurú - Venezuela
145 Florencia Sadous - Argentina
146 Alex Amelines - Colombia
147 Edward Stuart - USA
148 Carlos Riveroll - USA
149 Cinthia Cabero Mencia - Argentina
150 Evg3 Freelance Design -
 Abelardo Ojeda Flores Alatorre - Mexico
151 The Jaguar Negro Group -
 Argentina and Mexico
152 Jorge Aragón Muelle - Colombia
153 Olga Neva design - Colombia
154 iD2 Communications Inc. - Canada
155 Azul de Corso - Argentina
156 Pedro German Lopez Meza - Mexico
157 Ben Miller - USA

477 Fabian Geyrhalter - USA
478 Florencia Sadous - Argentina
479 Contigli Design - Argentina
480 Florencia & Santiago Sadous - Argentina
481 Macchi Azcuenaga - Argentina
482 Rafael Castaño Diseño - Argentina
483 Macchi Azcuenaga - Argentina
484 Jeff Fisher - USA
485 Tiago Brito Santana - Brazil
486 Design Quarry - Jack Born - Canada
487 Santiago Cichero - Argentina
488 Jeff Fisher - USA
489 Jeff Fisher - USA
490 Santiago Cichero - Argentina
491 Jerry King Musse - USA
492 Jill Haas - Shone Lumber - USA
493 Masa Critica design - Venezuela
494 Tiago Brito Santana - Brazil
495 Lawrence C. Paelmo - USA
496 Russ Yusupov - USA
497 Russ Yusupov`- USA
498 Russ Yusupov - USA
499 Jerry King Musse - USA
500 ML design - Mike Lenhart - USA
501 Russ Yusupov - USA
502 Azul de Corso - Argentina
503 Celis Bernardo design - Argentina
504 Ben Miller - USA
505 Design Quarry - Jack Born - Canada
506 Nohemí Dicurú - Venezuela
507 Marina Monteiro de Pamplona
 Côrte-Real - Brazil
508 Cats in the Bag Design -
 Jennifer Cook - Canada
509 Jerry King Musse - USA
510 Cats in the Bag Design -
 Jennifer Cook - Canada
511 ML design - Mike Lenhart - USA
512 Jerry King Musse - USA
513 Mike Gillerman - USA
514 Sarah Ruth Walker - USA
515 Mike Gillerman - USA
516 Masa Critica design - Venezuela
517 SmashLab - Eric Karjaluoto
 and Robert Young - Canada
518 Jerry King Musse - USA
519 Russ Yusupov - USA
520 Russ Yusupov - USA
521 SmashLab - Eric Karjaluoto - Canada
522 Rafael Castaño Diseño - Argentina
523 Kairos & Cronos design -
 Alvaro Heinzen - Uruguay
524 Design Quarry - Jack Born - Canada
525 Florencia Sadous - Argentina
526 SmashLab - Eric Karjaluoto - Canada
527 Estilo & Diseño - Claudio Hernando
 Gallego Ruiz - Colombia
528 Masa Crítica design - Venezuela
529 Masa Crítica design - Venezuela
530 Contigli design - Argentina
531 Nohemí Dicurú - Venezuela
532 Santiago Cichero - Argentina

533 Rafael Castaño Diseño - Argentina
534 Gramma publicidad -
 Cecilia Aguirre - Bolivia
535 Cuatro Piso - Alejandro Posada - Colombia
536 Ben Miller - USA
537 Alvaro de Melo Filho - Brazil
538 Design Quarry - Jack Born - Canada
539 Sandra Torres - Brazil
540 Adriana Costa e Silva - Brazil
541 Jeff Fisher - USA
542 Nohemí Dicurú - Venezuela
543 Santiago Cichero - Argentina
544 Catalina Estrada - Colombia
545 SmashLab - Eric Karjaluoto - Canada
546 Nohemí Dicurú - USA
547 Cuatro Piso - Carlos J. Roldán - Colombia
548 Ricardo Lopes - Brazil
549 Raineiro Cobos - Colombia
550 Scott Santoro - USA
551 Andre Gonzales - Brazil
552 Valon Sopaj - Lucid Vagabond -
 A Design Studio - USA
553 Azul de Corso - Argentina
554 Nohemí Dicurú - USA
555 Design Quarry - Jack Born - Canada
556 Waldomiro de Mello Moraes Neto - Brazil
557 Contigli design - Argentina
558 Cuatro Piso - Alejandro Posada - Colombia
559 Santiago Cichero - Argentina
560 Rafael Castaño design - Argentina
561 Gramma publicidad -
 Cecilia Aguirre - Bolivia
562 Jeff Fisher - USA
563 Ben Miller - USA
564 Adriana Costa e Silva - Brazil
565 Revolver design - Ricky Salterio - Panama
566 Marcelo de Faria Campos - Brazil
567 Design Quarry - Jack Born - Canada
568 Cats in the Bag Design -
 Jennifer Cook - Canada
569 Gramma Publicidad -
 Cecilia Aguirre - Bolivia
570 Scott Santoro - USA
571 Design Quarry - Jack Born - Canada
572 Valon Sopaj - Lucid Vagabond -
 A Design studio - USA
573 Dustin Ortiz - USA
574 Santiago Cichero - Argentina
575 Design Quarry - Jack Born - Canada
576 Valon Sopaj - Lucid Vagabond,
 A Design Studio - USA
577 Jeff Fisher - USA
578 Scott Santoro - USA
579 Scott Santoro - USA
580 Ricardo Lopes - Brazil
581 Scott Santoro - USA
582 Scott Santoro - USA
583 Scott Santoro - USA
584 Jeff Fisher - USA
585 Scott Santoro - USA
586 Tomás J. Pagán Cruz - Puerto Rico
587 Emerson Costa de Oliveira - Brazil

903 Estudio Cosgaya Diseño - Argentina
904 Olga Neva design - Colombia
905 Carlos Alberto Narváez - Colombia
906 Coeficiente - Hugo Lafuente - Paraguay
907 Susan Sabourin - USA
908 Nohemí Dicurú - Venezuela
909 Scott Santoro - USA
910 Masa Critica design - Venezuela
911 Handy & Randy
 Communication Inc. - Canada
912 Giovanni Arrieta - Colombia
913 Giotto - Ecuador
914 Carlos Alberto Narváez - Colombia
915 TMC Visionpool - Canada
916 Carlos Alberto Narváez - Colombia
917 Susan Sabourin - USA
918 Carlos Alberto Narváez - Colombia
919 Giotto - Ecuador
920 Juan Manuel Pedraza and
 Maurício Vargas - Colombia
921 Isabela Gava Ramires - Brazil
922 The Jaguar Negro Group -
 Argentina and Mexico
923 Design Quarry - Jack Born - Canada
924 Andre Rezende - USA
925 Fabian Geyrhalter - USA
926 Antonio F. Reboiro - Cuba
927 Daniel Abs da Cruz Bianchi - Brazil
928 Susan Sabourin - USA
929 Waldomiro de Mello Moraes Neto - Brazil
930 Jorge Aragón Muelle - Canada
931 Trama diseño - Rómulo
 Moya Peralta - Ecuador
932 Xigno comunicación y diseño - Román
 Pereyra Pérez and Yemina Mascareño
 Pedrote - Mexico
933 Design Quarry - Jack Born - Canada
934 Giotto - Ecuador
935 Design Quarry - Jack Born - Canada
936 Evg3 design - Abelardo
 Ojeda Flores Alatorre - Mexico
937 Flávia Regina da Motta Amadeu - Brazil
938 Lawrence C. Paelmo - USA
939 Gabriel Rezende Souza - Brazil
940 Xigno comunicación y diseño - Román
 Pereyra Pérez and Yemina
 Mascareño Pedrote - Mexico
941 Valon Sopaj - Lucid Vagabond`
 design Studio - USA
942 Design Quarry - Jack Born - Canada
943 Luciano do Monte Ribas
 and Micheli Lang - Brazil
944 Darcy Jans - Canada
945 Iron design - Todd Edmonds - USA
946 Susan Newman - USA
947 Florencia Sadous - Argentina
948 Pablo Daniel Correa Design - Argentina
949 Seth White - USA
950 Scott Santoro - USA
951 Design Quarry - Jack Born - Canada
952 Rodrigo Machado - Brazil
953 Scott Santoro - USA

954 Iron design - Todd Edmonds - USA
955 The Jaguar Negro Group -
 Argentina and Mexico
956 The Jaguar Negro Group -
 Argentina and Mexico
957 The Jaguar Negro Group -
 Argentina and Mexico
958 Evg3 design -
 Abelardo Ojeda Flores Alatorre - Mexico
959 Valon Sopaj - Lucid Vagabond
 design Studio - USA
960 Design Quarry - Jack Born - Canada
961 Jeff Fisher - USA
962 Kimberly Dakroub - USA
963 Jeff Fisher - USA
964 Igor de Sousa Saraiva - Brazil
965 Mikel Kohen - USA
966 Jeff Fisher - USA
967 Kimberly Dakroub - USA
968 Xigno comunicación y diseño -
 Román Pereyra Pérez - Mexico
969 Xigno comunicación y diseño -
 Román Pereyra Pérez - Mexico
970 Juan Torneros - Colombia
971 The Jaguar Negro Group -
 Argentina and Mexico
972 John W. Villari - USA
973 Design Quarry - Jack Born - Canada
974 David Begley - USA
975 Design Quarry - Jack Born - Canada
976 John W. Villari - USA
977 Oscar Luis Urrutia Blanco - Venezuela
978 Kenneth Paul Buras - USA
979 Luciano do Monte Ribas - Brazil
980 Jeff Fisher - USA
981 Kairos & Cronos design -
 Alvaro Heinzen - Uruguay
982 Clarissa Pawlowsky Patrianova - USA
983 Kairos & Cronos design -
 Alvaro Heinzen - Uruguay
984 Oscar Luis Urrutia Blanco - Venezuela
985 Coeficiente - Hugo Lafuente - Paraguay
986 Marina Monteiro de Pamplona
 Côrte-Real - Brazil
987 Oscar Luis Urrutia Blanco - Venezuela
988 Chad Upham - USA
989 Cale Peeples design - USA
990 Azul de Corso - Argentina
991 Gustavo Machado - Canada
992 Waldomiro de Mello Moraes Neto - Brazil
993 Design Quarry - Jack Born - Canada
994 Revolver design - Ricky Salterio - Panama
995 Oscar Luis Urrutia Blanco - Venezuela
996 Oscar Luis Urrutia Blanco - Venezuela
997 Celis Bernardo design - Argentina
998 Design Quarry - Jack Born - Canada
999 Oscar Luis Urrutia Blanco - Venezuela
1000 Rafael Furiati Luiz Martins - Brazil
1001 Revolver design - Peter Novey - Panama
1002 Carlos Alexandre Pontes Cid - Brazil
1003 Carlos Alexandre Pontes Cid - Brazil
1004 Ricardo Lopes - Brazil

INDEX BY NAME

www.adg.org.ar/
www.portalpublicitario.com
www.crann.com.ar
www.doma.tv/
www.conexionvisual.com.ar
www.commarts.com/
www.ogol.com.ar
www.sudtipos.com.ar
www.adcv.org.ar/
www.hyperfuente.com/
www.cmd.org.ar/
www.drez.com.ar/
www.australianinfront.com.au/
www.kiiroi.nu/
www.surfstation.lu/
www.thunkdesign.com
www.loslogos.org
www.juxtinteractive.com/
www.therevolution.com.au
www.pictoplasma.com
www.droppod.com/
www.lucidcircus.com/
www.one9ine.com
www.ignition13.com
www.pseudoroom.com/
www.mediainspiration.com/
www.opcd.net/
www.pulpit.it/
www.02designs.com
http://lounge72.com/01/
www.zonesdesign.com/
www.redrabit.com
www.sifoo.com/
www.hyperhex.com/
www.after5thirty.com
www.740creative.com/
www.8marchetti.com/
http://threeoh.com/atmosphere/
www.adukal.com
/www.halfproject.com/
www.linkodromo.com.ar/
www.abnormalbehaviorchild.com/
www.artedinamico.com
http://creartcol.tk/
www.cristalab.com
www.museovintage.com/
www.outlinemegadesign.com/
www.4ars.com
www.kacharreodigital.com/

http://kelgan29.com/
www.cubancouncil.com
www.designiskinky.net
www.vudumedia.com/
www.mondotrendy.com/
www.fdtdesign.com/
www.shift.jp.org/
www.threeoh.com/
www.tongsville.com/
www.arteye.com
www.experimental.ro/
www.visuellerorgasmus.de
www.designforchunks.com
http://digitalthread.com
www.fuelindustries.com

PLUS II

Want to study Design?
to teach?
to exchange experiences?

Check the next pages you will find some universities and
colleges around north, central and south America thant
teach design and art.

Enjoy it!

Argentina

Universidad de Buenos Aires
Ciudad Universitária,
Pabellon 3

**Universidade Nacional
de Córdoba**
Ciudad Universitária, pabellon
Arquitectura - Cordoba 5000

**Escuela de Diseño -
Facultad de Artes, Mendoza**
Centro Universitário,
Parque Gral. San Martin -
Cordoba 5500

**Universidade Nacional
de Mar del Plata**
Funes 3200 - Mar del Plata

**Universidade Nacional
de San Juan (UNSJ)**
Av. José Ignácio de la Roza y
Megliolli Complejo Universit.
Islas Malvinas - 5400 San Juan

Bolívia

Universidade Privada Boliviana
Av. Capitan Victor Ustariz. Km
6 1/2 - Campus UPB
www.upb.edu

**Universidade San Francisco
Xavier de Chuquisaca**
Calle Urriolagoitia 155
http://posgrado.usfx.edu.bo

Brazil

**Instituto Luterano de ensino
Superior - Ulbra**
Av. Solimaes nº 2
Conj. atilo andreazza
Bairro Japiim II -
69077 - 730 - Manaus
www.ulbra-mao.br

Centro Universitario Nilton Lins
Rua Marques de Monte Alegre,
1 /400 69058 - 040
www.uniniltonlins.com.br

**Universidade Federal
da Bahia - UFBA**
Rua Araújo Pinho, 212 - Canela
Salvador - BA - 40110 - 150

**Universidade Salvador -
INIFACS**
Av. Jorge Amado, 780,
Boca do Rio
41720 - 040 - Salvador - BA
design@unifacs.br
www.unifacs.br

**Universidade Federal do
Espirito Santo - UFES**
Av. Fernando Ferrari s/n -
CEMUNI I
Campus de Goiabeiras Vitória
Espirito Santo - 29060-900
www.ufes.br
www.car.ufes.br

Universidade Catôlica de Goias
CDUC Praça Universitária, 1440
Setor Universitaria Goiana
GO - 74605-010
www.ucg.br/deparcursos/
design_curso.htm

Universidade do Estado
de Minas Gerais - UEMG
Av. Amazonia, 6252 - Gameleira
Belo Horizonte - MG -
30510 - 000
www.uemg.br/design

Universidade Vale do Rio Doce
Rua Israel Pinheiro, 2000 -
Bairro universitário -
Governador Valadares
www.univale.br

Faculdade de engenharia e
arquitetura do Centro
Universitário - FEA - FUMEC
design@fumec.br
www.fumec.br

Universidade do Estado do Pará
Campus V - Travessa Doutor
Eneas Pinheiro, 2626 - Marco
Belem - PA - 66095-100
uepa_reitoria@prodepa.gov.pr

Universidade Federal
da Paraíba
Av. Aprigio Veloso, 882
Bodoconga
Campina Grande - PB -
58109 -970
www.ddi.ufpd.br

Centro de Educaçao Profissional
Rua Antônia Pietruza, 83 -
Porta 0 - Curitiba - PR
www.ensitec.com.br

CEFET
3165 Curitiba - PR - 82230-000
www.cefetpr.br

Universidade Estadual
de Londrina
www.uet.br

Universidade Tuiuti do Paraná
www.utp.br

PUC - PR
Rua Imaculada Conceiçao, 1155
- Prado Velho - Curitiba - PR -
80215-901

Universidade Federal do Paraná
Rua general Carneiro, 460 - 11°
andar Curitiba - PR - 80060-150
www.humanas.ufpr.br/grad.htm

Centro Universitário Positivo
Rua Pedro Viriato Parigot de
Souza, 5300 Curitiba - Paraná
www.unicenp.br

Universidade Federal
de Pernambuco - UFPE
Av. Prof Moraes Rego, s/n
Recife - PE - 50670-420

Escola Superior de Desenho
Industrial - ESDI/UERJ
Rua Evaristo da Veiga, 95 -
Lapa - Rio de Janeiro -
20031-040
www.esdi.uerj.br

Universidade Federal do RJ
www.eba.ufrj.br

UniCarioca
Av. Paulo de Frontin, 568
Rio de Janeiro
www.carioca.br

UniverCidade do Rio de Janeiro
Av. Epitácio Pessoa, 1664 - Rio
de Janeiro - 22471-000
www.univercidade.br

PUC- RIO
Rua Marques de Sao Vicente,
225 - RJ - 22453-041
www.puc-rio.br

Universidade Estácio de Sá
Av. Presidente Vargas 642 -
Centro - Rio de Janeiro -
20071-001
www.estacio.br

SENAI
Rua Dr. Manoel Cotrim, 195 -
Riachuelo - Rio de Janeiro -
20961-040
www.cetiqt.senai.br

**Escola de Ourivesaria
do Rio de Janeiro**
Rua Mariz e Barros,
678 - anexo
ourivesaria@rj.senai.br

Universidade Gama Filho
Av. das Americas, 500 - Barra
da Tijuca . Rio de Janeiro -
22640-100
www.ugf.br

**Universidade Estadual
de Pelotas**
Campus Universitário, s/n -
Caixa postal 354 96010-900 -
Pelotas, RS
www.ufpel.tche.br

**PUC - RS - Depto
Desenho Industrial**
Av. Ipiranga 6681,predio 30 -
Porto alegre - RS - 90619-900
http://music.pucrs.br/

**Universidade Federal
de Santa Maria - UFSM**
Campus Universitario - camobi
Santa Maria - RS - 97111-000
www.ufsm.br/index_cursos.html

Universidade Luterana do Brasil
Rua Miguel Tostes, 101 -
Caixa postal 124
Canoas - RS - 92420-280

FEEVALE - RS
Rua Emilio Hauschild, 70 - Vila
Nova - Novo Hamburgo - RS
93525-180
www.feevale.br

**Universidade do Vale
do Rio dos Sinos - UNISINOS**
Av. Unisinosw 950 Sao
Leopoldo - RS
www.unisinos.br

Universidade do Vale do Itajai
5th avenida, s/n Bairro dos
Muniípios 88330-000 Balneario
Camboriu - SC
www.bc.univali.br

Universidade Federal
de Santa Catarina - UFSC
cacev@cce.ufsc.br
www.egr.cce.ufsc.br/
comexvis.htm

Universidade do Estado de
Santa Catarina - UDESC
Av. Madre Benvenuta, 1907
Itacorubi - florianópolis - SC
www.udesc.br

Faculdade Barddal
Av. Madre Benvenuta, 416
Trindade - Florianópolis - SC
www.barddal.br

Uniao de Tecnologia e escolas
de Santa Catarina - UTESC
Rua viscondi de Taunay,
166 - Centro
Joinville - SC - 89201-420
www.utesc.br

Escola de artes
e design - Panamericana
Av. Angélica 1900 - 01228-200
Higienopolis - Sao Paulo
www.escola-
panamericana.com.br

SENAC - SP
Rua Scipico,67 -
Sao Paulo - SP
cca@sp.senac.br
www.sp.senac.br

Fundaçao Armando
Alvares Penteado
www.faap.br

Faculdade de Tecnologia de Birigui
Rua. antonio Simoes, 4 Birigui - SP
www.infocenter.com.br

Faculdades Integradas Teresa D´Avila -
FATEA
Av. Peixoto de castro, 494 Lorena - SP
12600-000
www.fatea.br

Faculdadede Belas Artes de Sao Paulo
- FEBASP
Rua Alvaro Alvim, 76 - Vila Mariana
Sao Paulo - SP -. 04018-010
www.belasartes.br

Universidade de Guarulhos - UnG
Praia Tereza Cristina, 01 Guarulhos -
SP
07020-070

Universidade Estadual Paulista
Av. Eng. edmundo Carrijo Coube, s/n -
Vargem Limpa, Bauro - SP - 17033-360

Universidade de Franca - UNIFRAN
Anel Viario, Km 3 - caixa postal 082
Franca - SP 14400-000
www.unifran.br

Universidade Paulista - UNIP
Rua Dr. Barcelar, 1212 - Mirandópolis -
sao Paulo - SP 04026-002

Universidade Anhembi Morumbi
www.anhembi.br

Universidade Mackenzie
Rua Maria antonia, 403 -
Villa albuquerque -
caixa Postal 8792
Sao Paulo - Sp - 01222-010

Universidade Sao Judas Tadeu
Rua Taquari, 546 - Bloco A sao
Paulo - SP - 03166-000

Universidade Bandeirantes
de Sao Paulo - UNIBAN
Av. Dr. Rudge Ramos, 1501 -
Rudge Ramos Sao Bernardo do
Campo - SP - 09736-300
www.uniban.br

Universidade Tiradentes - UNIT
Rua Lagarto, 264 Centro -
49010-390 Aracaju - SE
www.unit.br

Canada

Carleton University School
of Industrial design
3470 Mackennize Building . 1125
Colonel by Drive - Ottawa,
Ontario k15 - 5b6
www.id.carleton.ca

CEGEP Dawson
www.dawsoncollege.qc.ca

CEGEP de Sainte - Foy
www.cegep-ste-foy.qc.ca

CEGEP du Vieux Montreal
255, rue Ontario Est - Montreal,
QUE H2X 1X6
www.cvm.qc.ca

Emily Carr Institute
of Art and Design (ECIAD)
1399 Johnston Street -
Vancouver, Bristish Columbia
V6H - 3R9
www.eciad.bc.ca

Fanshawe College
1460 Oxford street East P.O
Box 4005 - London, Ontario
N5W - 5H1
www.fanthawec.on.ca

Georgian College
One Georgian Drive, Barrie, ON
L4M 3X9
www.georgianc.on.ca

Humber College
205 Humber college Boulevard
Toronto, ON M9W5L7
http://appliedtechnology.hum-
berc.on.ca

International academy of design
1253, avenue Mc Grill college,
10th floor
Montreal, quebec H3B 2Y5

International Language
academy of Canada
920 Younge Street, 4th Floor
Toronto, Ontario, M4W 3C7

Nova Scotia college
of art and design
www.nscad.ns.ca

Ontario College
of Art and Design
100 Mc Caul St Toronto,
Ontario, Canada M5T 1W1
www.ocad.on.ca

Replica 3D Animation School
1400A Marsland Place
Courtenay, B.C. V9N 8X7
www.replica3d.ca

University of Alberta
3-98 Fine arts building
University of alberta edmonton,
Alberta T6G - 2C9
www.ualberta.ca

University of Calgary
2500 University Drive, N.W.
Calgary, alberto T2N - 1N4
http://www.ucalgary.ca/evds/

Université de Montreal
Pavillon 5620 Darlington
Montreal, QUE
www.din.umontreal.ca

York University /
Sheridan College
4700 Keele street Toronto,
Ontario, M3J 1P3

Chile

Escuela de diseño de la
Universidad Diego Portales
Republica 180 - santiago
www.udp.cl

Escuela de Diseño de la
Universidad Tecnologica
Metropolitana
www.utem.cl

Universidad de Valparaiso -
escuela de Diseño
Valparaiso Chile

Universidad de Chile
Marcoleta n° 250 - santiago
www.fau.cl

Universidad del Pacífico
Av. Las Condes 1 1121 - Las
condes - santiago
www.upacífico.cl

Universidad UNIACC
Av. Salvador 1200 -
Providencia
www.uniacc.cl

Colombia

Facultad de Arquitectura y
Diseño - Universidad Javeriana
Carrera 7 nº40-62 Santa fe de
bogota - Cundinamarca
www.javeriana.edu.co

Universidade Autonoma
de Manizales
Antigua estacion de El ferroca-
rril - Manizales, Caldas
www.autonoma.edu.co

Universidade
Jorge Tadeo Lozano
Carrera 4 nº 22 - Bogota
www.utadeo.edu.co

Universidade Piloto de Colombia
CR 8 nº 45 bogota,
cundinamarca

UniversidadePontífica
Bolivarian, Escuela de
Arquitectura y diseño
circular 1a. nº 70 Laureles -
Medellon, antioquia
www.upb.edu.co

Universidade de los Andes
Cra. 1 nº 18A - 10 santafe
de Bogota, D.C.
www.uniandes.edu.co

Universidade Icesi
Calle 18 nº 122 (Pance) - Cali
www.icesi.edu.co

Universidade Nacional de
Colombia, Facultad de artes
www.unal.edu.co

Costa Rica

Crearte
Box 1877 - 1002 grécia , Costa Rica

Instituto Tecnologico de Costa Rica
cartago, costa Rica Apdo 7050
Cartago, Costa rica

Cuba

Universidade AlmaMater
casa Editora Abril: Prado 553 esq.
a Tte. rey 10200 Habana Vieja - ciudad
de la habana - cuba
www.almamater.cu

La Universidade Cubana
www.mes.edu.cu

Dominican Republic

Instituto Tecnologico
de Santo Domingo (INTEC)
Av. Los Proceres, Gala -
Santo Domingo
www.intec.edu.do

Ecuador

Universidad Santa Maria
Av. Carlos Julio Arosemena km
4,5 - Guayaquil
www.usm.edu.ec

Guatemala

Universidad Rafael Landivar
Campus central Villa Hermoza III,
Zona 16
www.landvar_guatemala.encuadre.org

Mexico

**Escuela de Diseño del Instituto
Nacional de Bellas Artes**
Xocongo N 138, col Transito - 06820,
D.f. Mexico

**Escuela de Diseño del Instituto
Tecnológico de Estudios Superiores
de Occidente (ITESO)**
Periferico Sur 8585
Tlaquepaque 45090, Jalisco
www.iteso.mx

**Escuela de diseño -
universidad anahuac Huixquilucan**
av. de las torres 131, olivar de los
Padres 01780 alvaro Obregon,
distroto federal
http://anahuac_sur.encuadre.org

**Escuela de Diseño Industrial
de la Universidad Autonoma
de Guadalajara - Jalisco**
Xocongo N 138. Col Trnsito
06820 Mexico D.F

**Instituto Tecnológico y de Estudios
Superiores de Monterrey (ITESM)**
Av. Eugenio Garza Sada n° 2501
Sur. de correios "J" Monterrey
Nuevo Leon 64849
www.mty.itesm.mx

**UNAM - Centro de Investigaciones
de Diseño Industrial**
Circuito Escolar s/n
Ciudad Universitária
UNAM - Mexico D.F 04510
http://ce-atl.posgrado.unam.mx

UNAM - Fac de arquitectura
Circuito Escolar s/n Ciudad
Universitária UNAM - Mexico D.F
http://ce-atl.posgrado.unam.mx

**Universidad Iberoamericana -
Colonia Lomas de Santa Fe**
www.uia.mx

Universidad Intercontinental
Insurgentes sur 4303, colonia Santa
Úrsula Xitla 14420 Tlalpan, d.F.
www.uia.mx

Universidad de Guadalajara
www.cuaad.udg.mx

Mexico

Universidad Iberoamericana - Noroeste
Av. Centro Universitario 2501,
Fraccionamiento Playas de
Tijuana 22200 Tijuana,
Baja California
http://ibero_tijuana.encuadre.org

Universidad Iberoamericana
Carretera Federal Puebla-
Atlixco, Km 3,5
72430 Puebla, Puebla
22200 Tijuana Baja California
http://ibero_puebla.encuadre.org

Universidad del Valle de México
San Juan de Dios 6
14370 Tlalpan, Distrito Federal
http://uvm_tlalpan-encuadre.org

Universidade Autônoma Metropolitana
Av. San Pablo 180 Colonia
Reynosa
Tamaulipas 02200 azcapotzalco
http://uam_azcapotzalco.
encuadre.org

Universidade autônoma Metropolitana
Calzada del Hueso 1100, edificio
DG México DF 04960 México
http://alebrije.uam.mx/dcg

Universidade Anáhuac del Sur
Av. de la Torres 131, Olivar de
los Padres 01780 Alvaro
Obregon

Universidad Autonoma de Guadalajara
Av. Patria 2215 Guadalara,
Jalisco
www.uag.edu

Universidade Autônoma de Aguascalientes
Av. Universidad 940, edificio
108 20100
Aguascalientes
http://ua_aguascalientes.
encuadre.org

Universidad Nacional Autonoma de Mexico
Cd. Universitária, Faculdad
de Arquitectura
Mexico D.F
www.uam.mx

Universidade Autonoma Metropolitana
Calzada del hueso 1100, edificio
DG Mexico
DF 04960 Mexico
http://alebrije.uam.mx/dcg

Universidade Autonoma Metropolitana
San Pablo 180 Mexico DF,
02200
www.uam.mx

Universidade de Monterrey
Morones Prieto 4500
poniente san Pedro
arza Garcia, Nuevo Leon 66238
www.udem.edu.mx

Universidad La Salle
http://la_salle.encuadre.org

Universidade Latina de Mexico
Paseo del Bajio y magnolia,
colonia Jardines de Celaya
38080 celaya, Guanajuato

Universidade Nacional
Autonoma de Mexico
Escuela Nacional de artes
Plasticas av. Constitución 600
Barrio la concha 16210
Xochimilco, distrito Federal
http://unam_enap.encuadre.org

Universidade Nacional
Autonoma de México
Escuela Nacional de estudios
Av. Alcanfores s/n, san Juan
totoltepec 53150 Naucalpan de
juarés, estado de Mexico
http://unam_enep_acatlan.
encuadre.org

Universidade Popular
Autonoma del estado de Puebla
21 Sur 1103, colonia santiago
72160 Puebla, Puebla
http://upaep.encuadre.org

Universidade autonoma de
San luis Potosí Faculdade
del Habitat
http://habitat.uasip.mx

Universidad Tecnologiva
de Mexico
http://unitec.encuadre.org

Universidad Vasco de Quiroga
http://uvaq_morelia.
encuadre.org

Universidad Anáhuac Poniente
Av. Lomas anáhuac s/n
52786 Huixquilucan, estado de
Mexico
http://anahuac_pte.encuadre.org

Universidade
Tecnólogicaq Americana
Viaducto Miguel aleman 255
colonia roma Sur 06760
mexico D.F
http://uteca.encuadre.org

Universidad Simón Bolivar
Av. Rio Mixcoac 48 colonia
Insurgentes Mixcoac 03920
mexico D.F
http://simon_bolivar.
encuadre.org

Panama

Universidade
ecnológica de Panamá
Apdo Postal 6 2894, el dorado
Panamá
http:www.utp.ac.pa

Universidade católica
santa Maria la Antigua
Via ricardo J. Alfaro, Panamá
www.usma.ac.pa

Paraguay

Universidade Catôlica Nuestra
Señora de la asuncion
Tte. Cantaluppi y
Villalón C.C. 1683
www.uca.edu.py

Universidade americana
Av. Brasilia 1100
www.uamericana.edu.py

Peru

Pontífica Universidad
Católica del Peru
Av. Universitária c.18
San miguel city state
lima Peru
www.pucp.edu.pe

USA

Advanced computing Center for
the arts and design (ACCAD)
www.crgrg.ohio-state.edu

Academy of Art College
79 New Montgomery street san
Francisco Ca 94105
www.academyart.edu

Academy of entertainment
technology
1660 stewart street
Santa monica CA 90404
http://academy.smc.edu

Antonelli College
www.antonelli.com

Arizona State University
www.asu.edu

Art Center College of design
www.artcenter.edu

Art Institute of Colorado
1200 lincoln Street Denver Colorado
www.aic.artinstitutes.edu

The Art Institute of Fort Lauderdale
1799 S E 17th Street Fort
Lauderdale, FL 33316
www.aifl.artinstitutes.edu

Art Institutes International Minnesota
15 South 9th Street Minneapolis,
MN
55402
www.aim.aii.edu

The Art Institute of Pittsburgh
420 Boulevard of Allies Pittsburgh
Pennsylvania 15219
www.aip.artinstitutes.edu

Auburn University
www.auburn.edu/ind

Ball State University
www.bsu.edu

Bassist College
2000 SW 5th Av. Portland OR 97201

Bemidji State University
1500 Birchmont Drive NE Bemidji,
MN 56601-2699
www.bemidji.msus.edu

Brigham Young University
www.byu.edu

Cal Poly - San Luis Obispo
www.calpoly.edu

Interdisciplinary Product
Development at BYU
www.et.byu.edu

California College
of Art + Crafts (CCAC)
1111 Eighth street San Francisco,
CA 94107
www.ccac-art.edu

California State University
www.csulb.edu/design

California state University, Northridge
www.csun.edu

Carnegie Mellon University
www.cmu.edu

Center for Electronic Art
250 4th street
San francisco, CA 94103
www.cea.edu

Center for creative Studies
www.ccscad.edu

Central Connecticut State University
1615 Stanley street New Britain, CT
06050-4010
www.design.ccsu.edu

Cleveland Institute of Art
11141 East Boulevard Cleveland,
OH 44106
www.cia.edu

The Colorado Institute of Art
200 E. 9th Ave. Denver, CO 80203
www.cia.aii.edu

Columbia College Chicago
600So. Michigan Ave. Chicago,
Illinois 60605
www.colum.edu

Cornish College pf the Atrs
710 E. Roy st. Seattle, WA 98102-9846
www.cornish.edu

Cranbrook academy of Art
39221 Woodward Avenue, Box 801
www.cranbrookart.edu

DH Institute of Media Arts
1315 3rd St. Promenade, 3rd
Flr.
santa Monica, california
www.dhima.com

Franklin Marshall College
P.O Box 3003 Lancaster, PA
17603
www.fandm.edu

Georgia Institute of Technology
www.gatech.edu

Georgia Tech IDSA
www.mindspring.com

Hampton University
www.hampton.edu

Herron School of art IUPUI
www.herron.iupui.edu

Internacional academy of
Merchandising and Design
www.iamd.edu

ITT Technical Institute
4919 Coldwater Road
Fort Wayne, Indiana 46825
www.itt-tech.edu

ITT Technical Institute
920 West Levoy Drive
Murray, UT 84123
www.itt-tech.edu

Illinois institute of technology
www.id.iit.edu

Kansas City Art Institute
www.kcai.edu

Kalamazoo Valley
Community College
www.kvcc.edu

Kendall College
of Art and Design
www.kcad.edu

Maryland Institute College of Art
1300 Mount Royal Avenue
Baltimore, MD 21217
www.mica.edu

Massachusetts College of art
621 Huntington Ave.
www.massart.edu
www.mca.edu

Metropolitan state
College of Denver
http://engrtec2.mscd.edu

Milwaukee Institute
of art and Design (MIAD)
www.miad.edu

Minneapolis College
of art and Design
www.mcad.edu

Mississippi State University
www.sarc.msstate.edu

North Caroline state University
www.ncsu.edu

Northern Illinois university
www.niu.edu

New York Institute of technology
1855 Broadway New York NY
10023
www.nyit.edu

Ohio State University
www.cgrg.ohio-state.edu

Parsons School of Design
66 fifth Ave. New York NY 10011
www.parsons.edu

Philadelphia University
www.philau.edu

Pratt Institute
www.pratt.edu

Purdue University
www.purdue.edu

Rhode Island School of Design
www.risd.edu

Ringling School
of Art and Design
www.rsad.edu

Rochester Institute
of Technology
www.rit.edu

Rocky Mountain College
of art and Design
www.rmcad.edu

San Diego state University
5500 Campanile Drive
http://psfa.sdsu.edu

san Francisco State University
1600 Holloway Ave.
San francisco CA 94132
http://dai.sfsu.edu

San José State University
www.sjsu.edu

Savannah College
of Art and Design
www.scad.edu

School of visual
Arts - MFA Design
www.schoolofvisualatrs.edu

Southern Illinois University
www.siuc.edu

Stanford University
http://design.stanford.edu

Stockton College
www.stockton.edu

syracuse University
www.syr.edu

Towson University
www.towson.edu

Tyler School of art of Temple U.
www.temple.edu

University of arts
www.uarts.edu

University of Bridgeport
www.bridgeport.edu

University of California
at Los angeles
www.ucla.edu

University of Cincinnati
www.uc.edu

University of Ilinois at Chicago
www.uic.edu

University of Illinois
at Urbana /Champaign
http://gertrude.art.uiuc.edu

University of Kansas
http://kufacts.cc.ukans.edu

University of notre Dame
www.nd.edu

University of
lousiana at Lafayette
www.lousiana.edu

University of Washington
www.washington.edu

University of wisconsin at Stout
www.stout-id.com

Utah state University
www.usu.edu

Virginia Polytechnic Institute
and state University
www.vt.edu

Virginia Marti College
of Fashion and art
www.virginiamarticollege.com

University of Michigan
www.umich.edu

State University of New York
www.newpaltz.edu

Wentworth Institute
of Technology
www.wit.edu

western Michigan University
www.wmich.edu

Westlawn Institute
of Marine Technology
www.westlawn.com

West Valley College
www.wvcid.edu

Western Washington University
www.wwu.edu

Yale school of Art
www.yale.edu

Uruguay

Centro de Diseño Industrial
Miguelete 1825 - montevideo
cedei@adinet.com.uy

School of design ORT
University of Uruguay
Mercedes 1199 -
Montivídeo 11.100
carmenes@ort.edu.uy

Venezuela

Instituto de Diseño de Caracas
www.disegno.com

Escuela de diseño Gráfico - FAD
carrozmora@cantv.net

BIBLIOGRAPHY

American Marketing association
Você S.A
www.core77.com
www.adg.com.ar
www.aiga.org
www.adgecuador.com
www.gdc.net
www.encuadre.org
www.elcirculo.net

PEDRO GUITTON

Brand Identity Developer

A Brazilian-born, Spanish citizen.
Graphic designer with an MBA in Marketing,
currently doing a PhD in "Personal Branding".

He teaches at the IED - Istituto Europeo di Design and
has given talks on graphic design, corporate identity and
urban culture throughout the world. He is the author of
the books: Fashion Identity, The Bags, 100% Design
Portfolio, DNA Identity, T-Shirt 360*, Logos do Brasil
and Marca 2000.

His graphic influences come from a mix of experiences
acquired in the places he where has lived, worked and
studied: Rio de Janeiro (happiness and beauty),
California (style and dream) and Barcelona, his current
city (art and history).

www.pedroguitton.com
www.mitodesign.com

Mito
Branding Design